Discovery Of Life

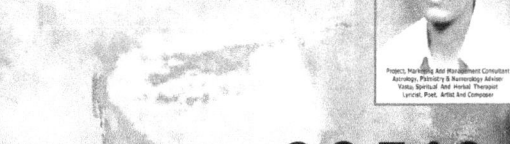

Origin, Evolution, And Creation

Adiya Kumar Daga

Discovery Of Life
(Origin, Evolution And Creation)

Only For People Aged 15+

Dedicated To

All who were a Part of my life

**And to All for whom I imagine or dream
to be a part of my life but
they couldn't be.**

**Special dedication to all who believe in
mysteries of origin, strange discoveries of
living beings, strange relations of fire and air,
burning desires, hidden dreams, inexplicable sins
and a unique combination of dark & light within**

Original Arts based on the theory of Discovery, Origin And Evolution of Life. All Art Works are sketched, painted & composed By Aditya Kumar Daga .

3C Gopi Bose Lane Kolkata-700012; W.B; India

Web : - www. adityaastroworld@gmail.com

Email: - adityaastroworld@gmail.com

Mob: +91 9432221255, +91 8961429776

First Edition on 30th September 2016

Other Published Book By www.createspace.com (Unit Of Amazon)

Original Art Work
- Creation Of Universe : Nature in My Vision Disaster & Creations
- Journey Of Soul : It's Journey never ends.
- Kid's Dream Word : Lovely Imaginations & Simple Thoughts

Motivation & Enlightenment
- Out Of Mind : Confusions Vs Reality

Copyright @ Aditya Kumar Daga No Part shall be copied or produced or reproduced without the written permission of the Writer, Artist & Author Aditya Kumar Daga

Preface

How origin of acellular (having no cellular structure) organism or cellular organism happen & evolved billion years ago is still a mystery half resolved and half explored. Many such organisms are almost extinct today but the extinction of such organisms no way stopped the more evolution of many new kind of acellular & cellular organisms. Virus is the acellular smallest sub microscopic and most primitive living organism having no locomotion and have evolved in more then 3000 types.

Other category organisms are unicellular prokaryotic less complex bacteria's which are also recorded as most primitive forms of life around 3.2 billions years old. They are parasitic and have locomotion. They contain no cellulose & composed of nitrogenous compounds and carbohydrates and usually evolved & found in every corner of earth and water and may be in many other parts of the universe still in exploration. Bacteria's usually reproduce asexually that is vegetative reproduction through simple fission of cells. A few bacteria in living being also found to be sexually reproduced called bacterial conjugation.

Other primitive organisms Algae which are simple unbranched row or filament of cells are found in ponds, ditches, pools & rivers & used even for consumption by other living beings since the evolution of life of any kind. Algae is also evolved through asexual & sexual reproduction depending on different kinds of Algae.

Fungi and yeasts are also a very primitive organism unicellular, having no chlorophyll living mostly as saprophytes or parasites on living or dead beings or organisms. It's reproduction is also asexual & sexual both.

Rest of the specie s like Bryophytes, Pteridophytes, Gymnosperms, Angiosperms, animal kingdom & human life all have sexual reproduction since the evolution of all these genres post origin & evolution of earth. Similar may be the theories behind the creatures & organisms if living or available in other parts of the Universe.

Some scientists proved that life originated through chemosynthesis or formation happened due to interaction of biochemical's where the first lighter elements of surface like oxygen, hydrogen, nitrogen and carbon get interacted with each other due to variation in temperature and formed water, ammonia, molecular hydrogen & carbon dioxide which in turn come into the random interaction of fire and energy produced by ultraviolet radiations, cosmic rays, lightening and hot lava from volcanoes and formed sugars, amino acids, alcohols, fatty acids, nucleotides and many other bio chemicals. Interactions goes on due to different form of heat, fire and energy and complex organic molecules were formed. There aggregation formed colloidal complexes that finally developed covering membrane and nucleic acids to produce PROTOCELLS or so called PRIMITIVE CELLS the cause of "DISCOVERY OF LIFE".
(But many spiritualist still favors one simple theory that God is behind the "DICOVERY OF LIFE").

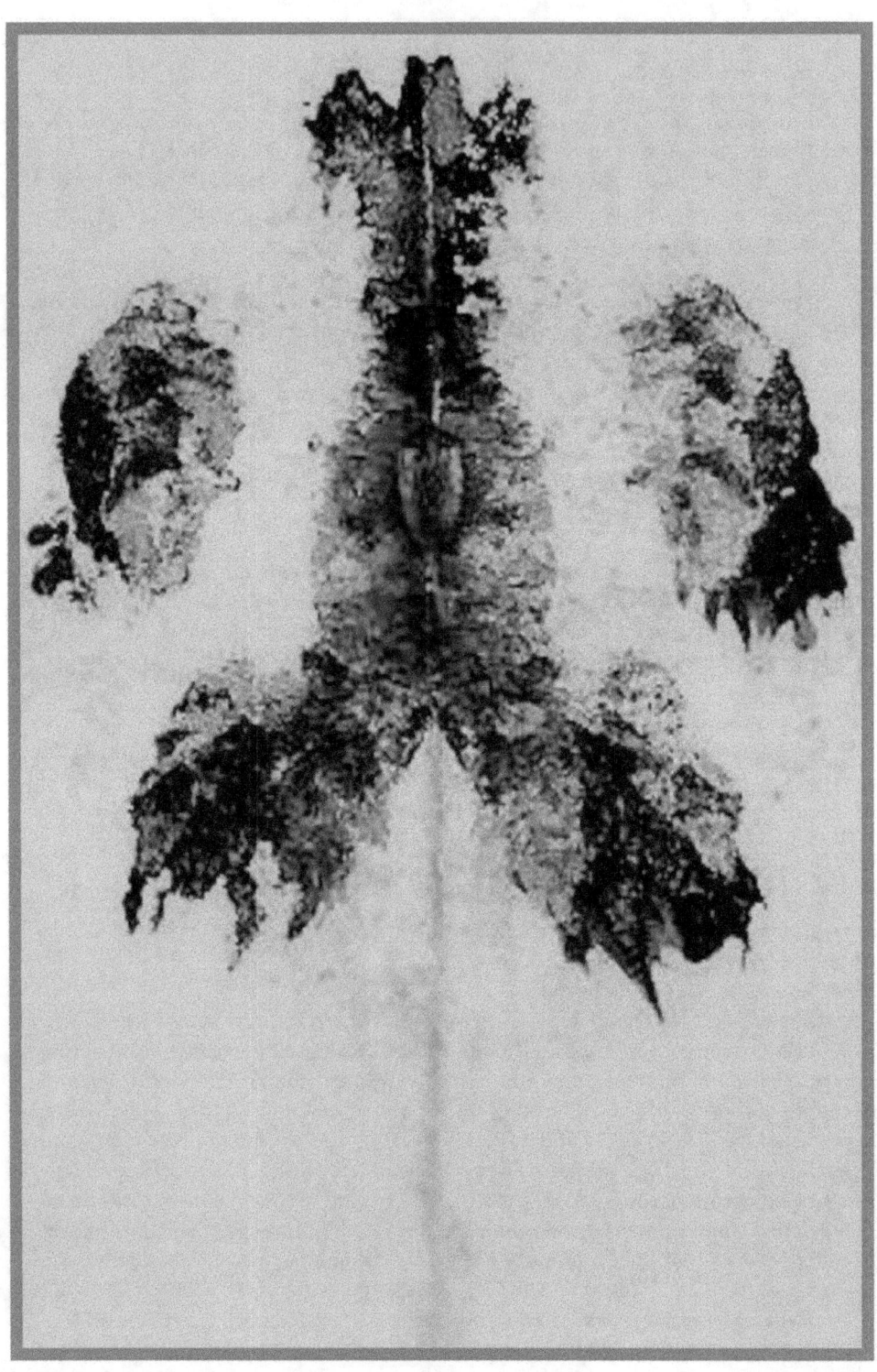

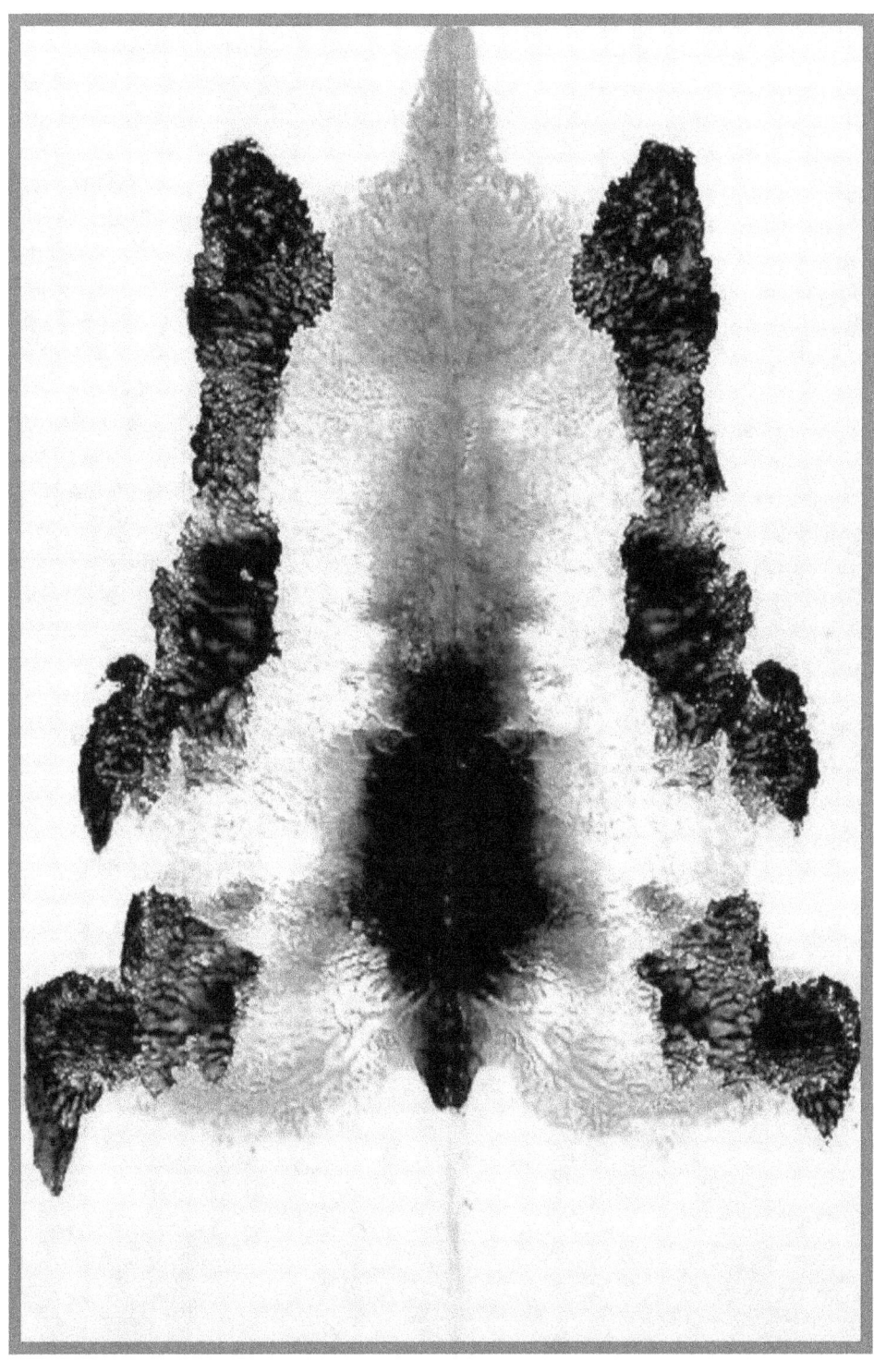

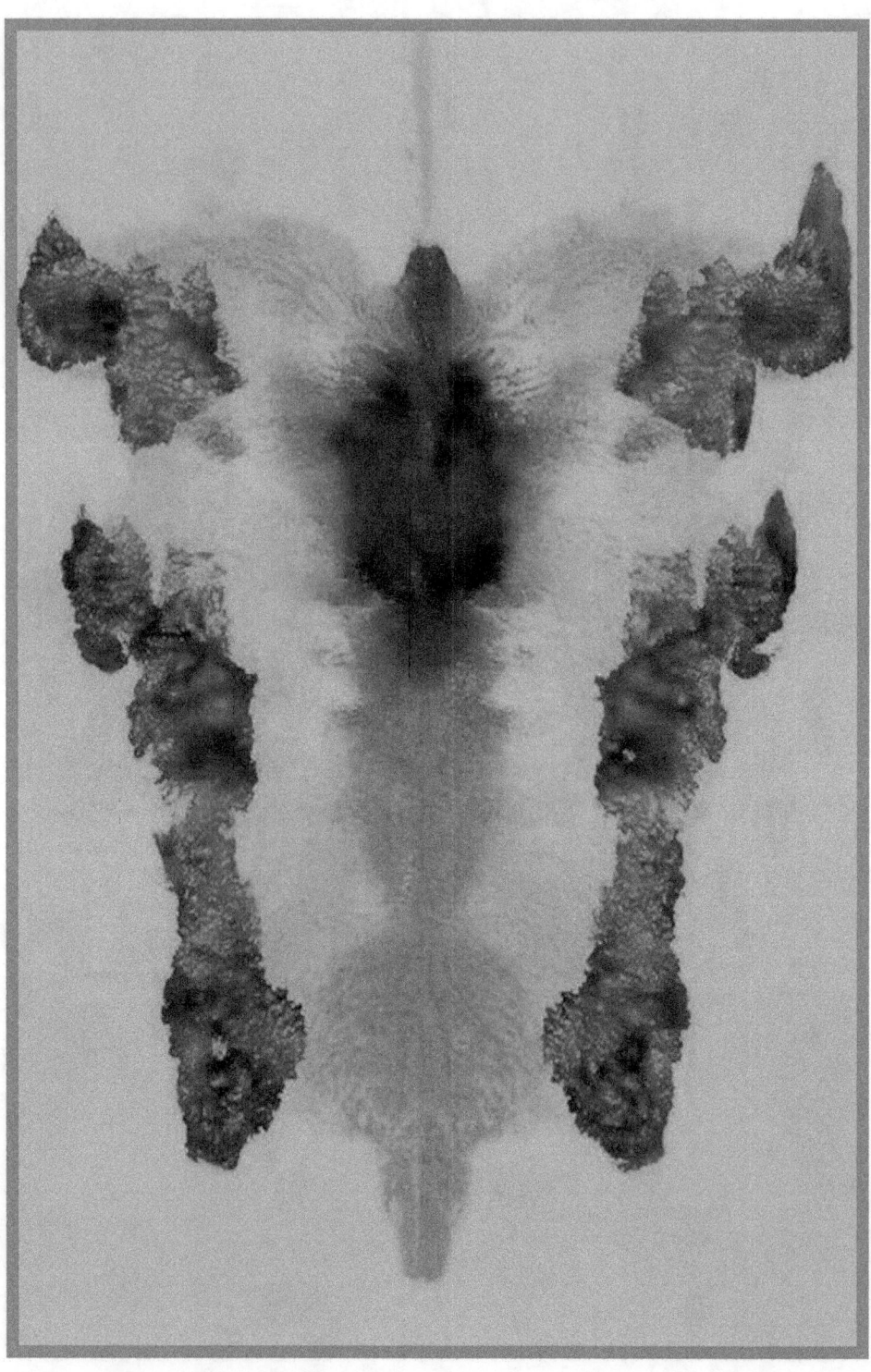

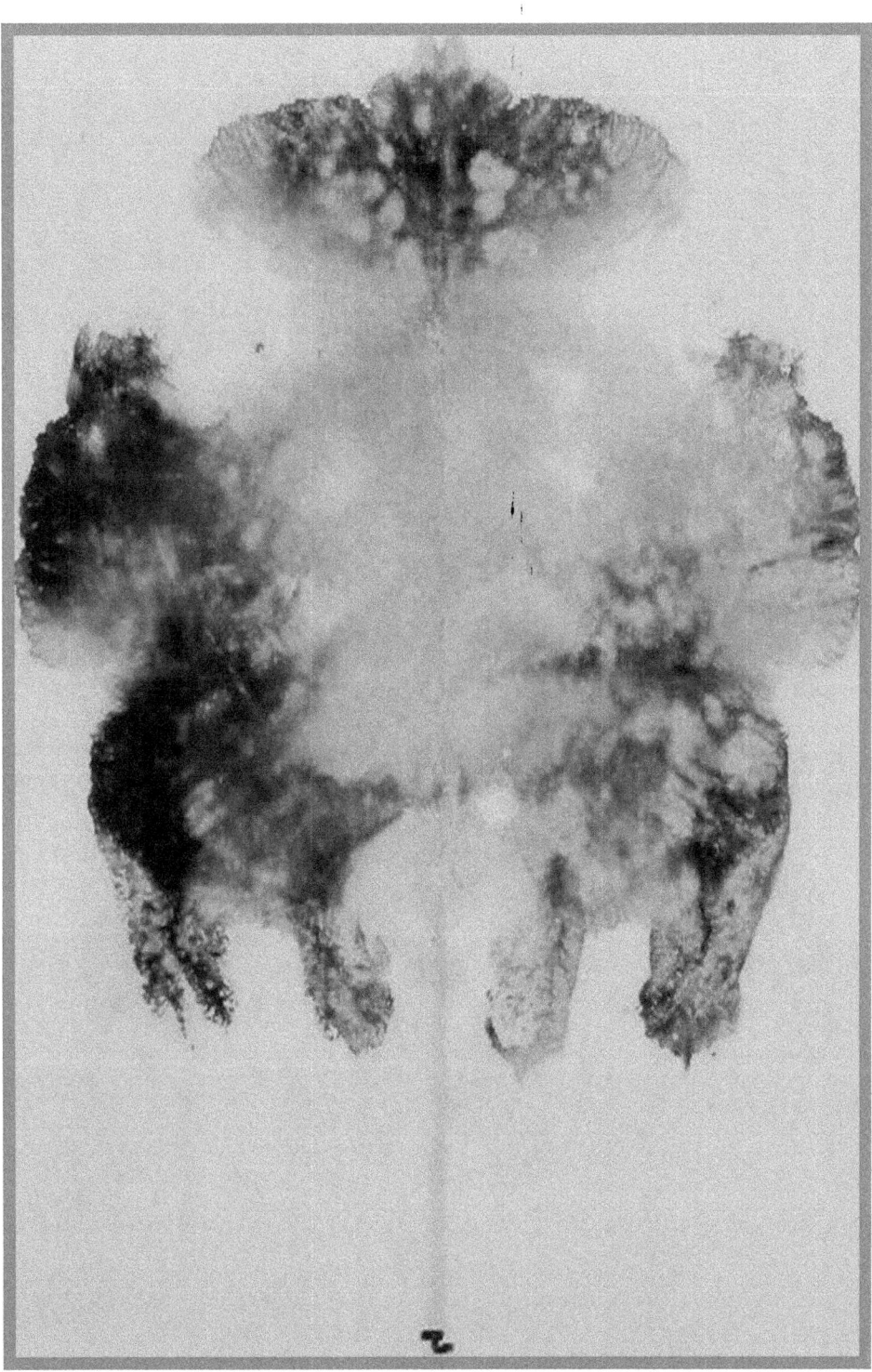

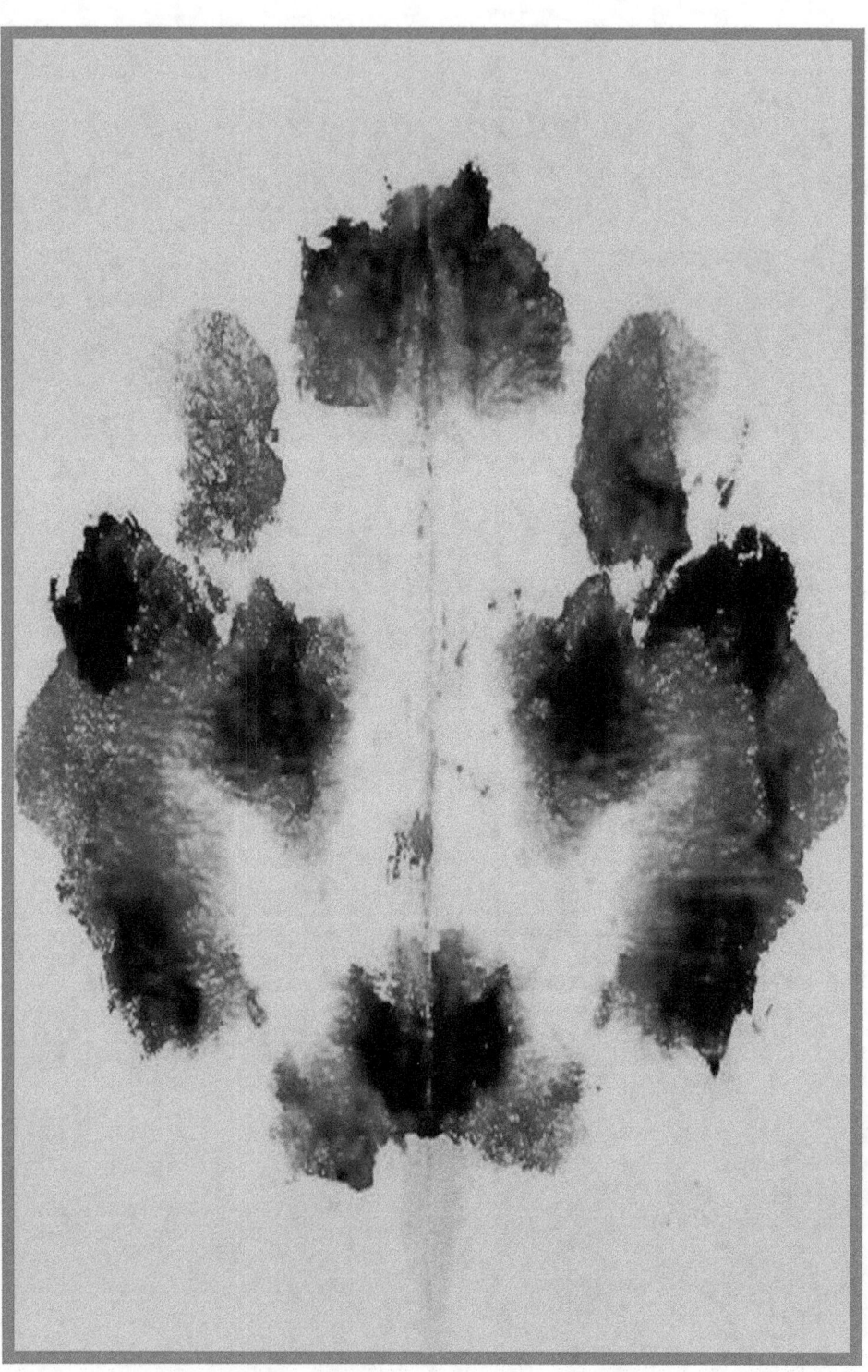

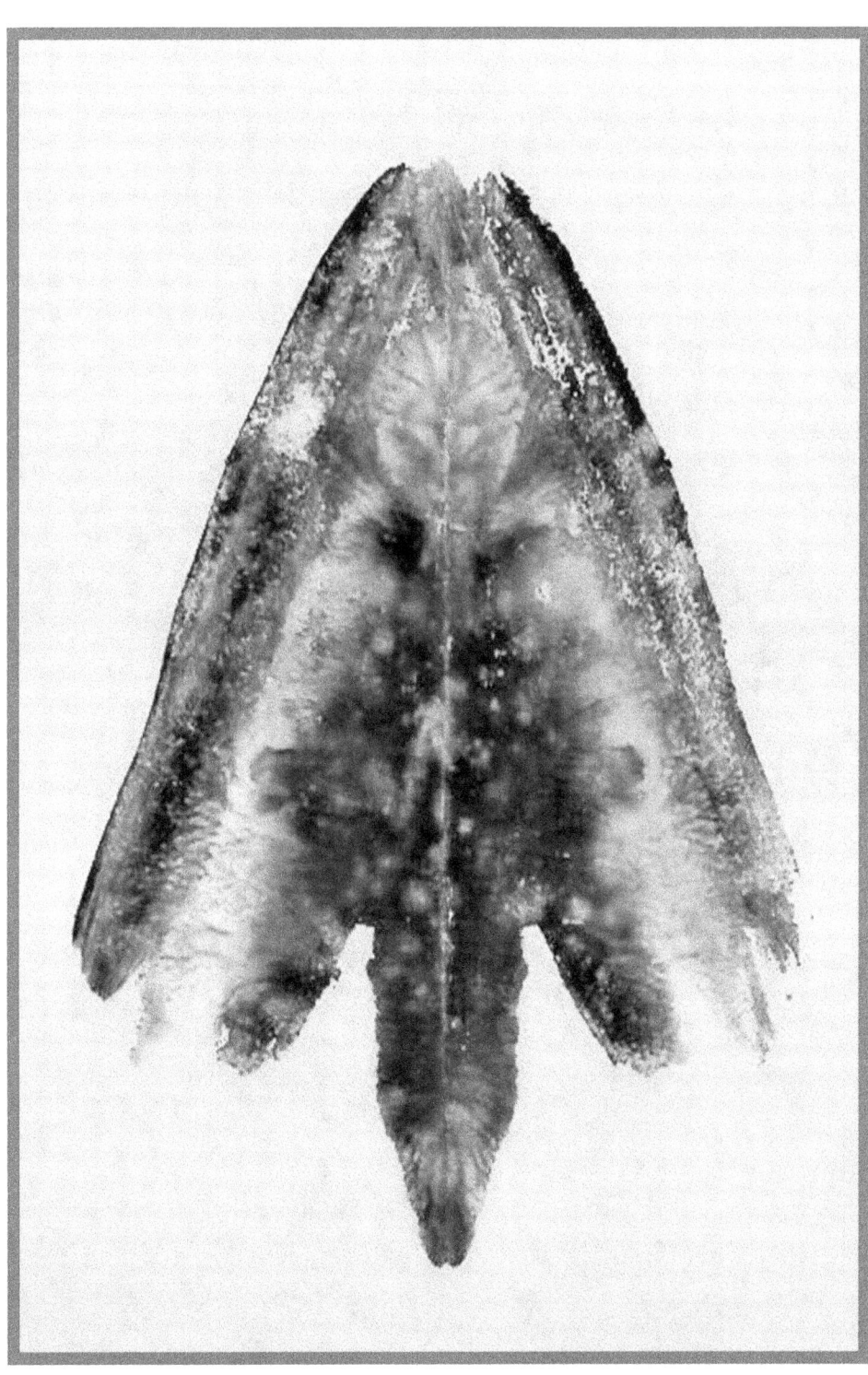

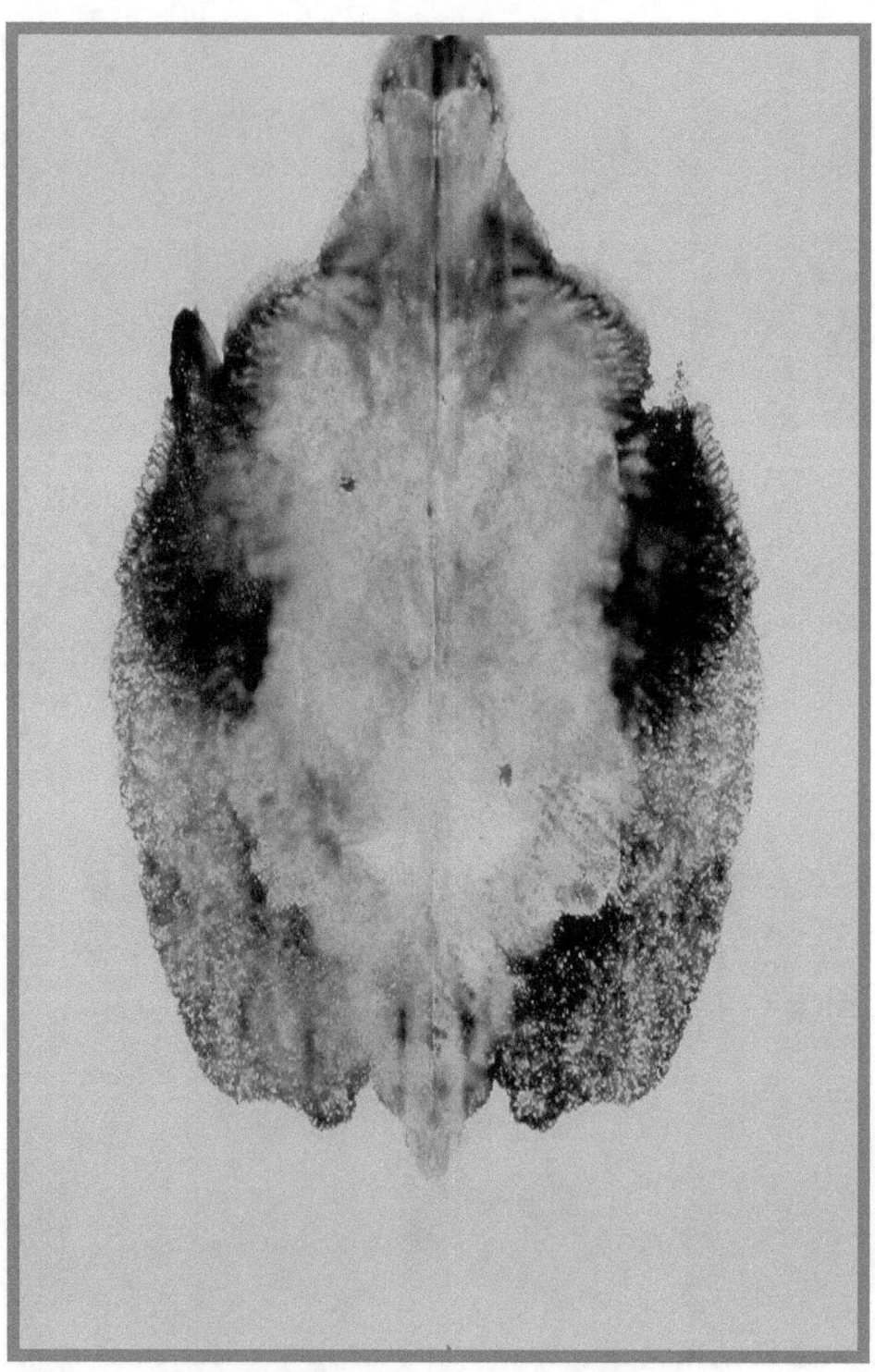

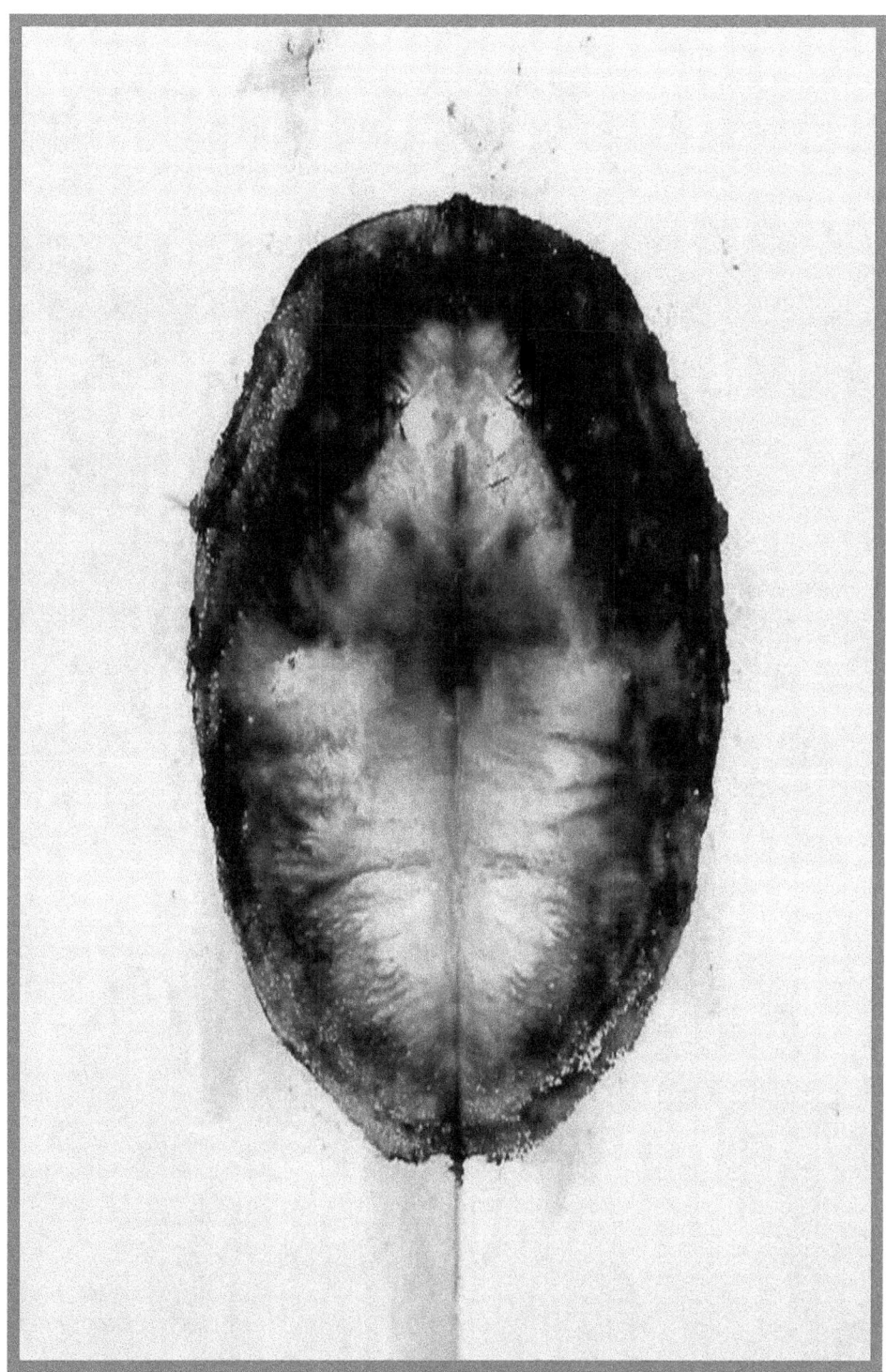

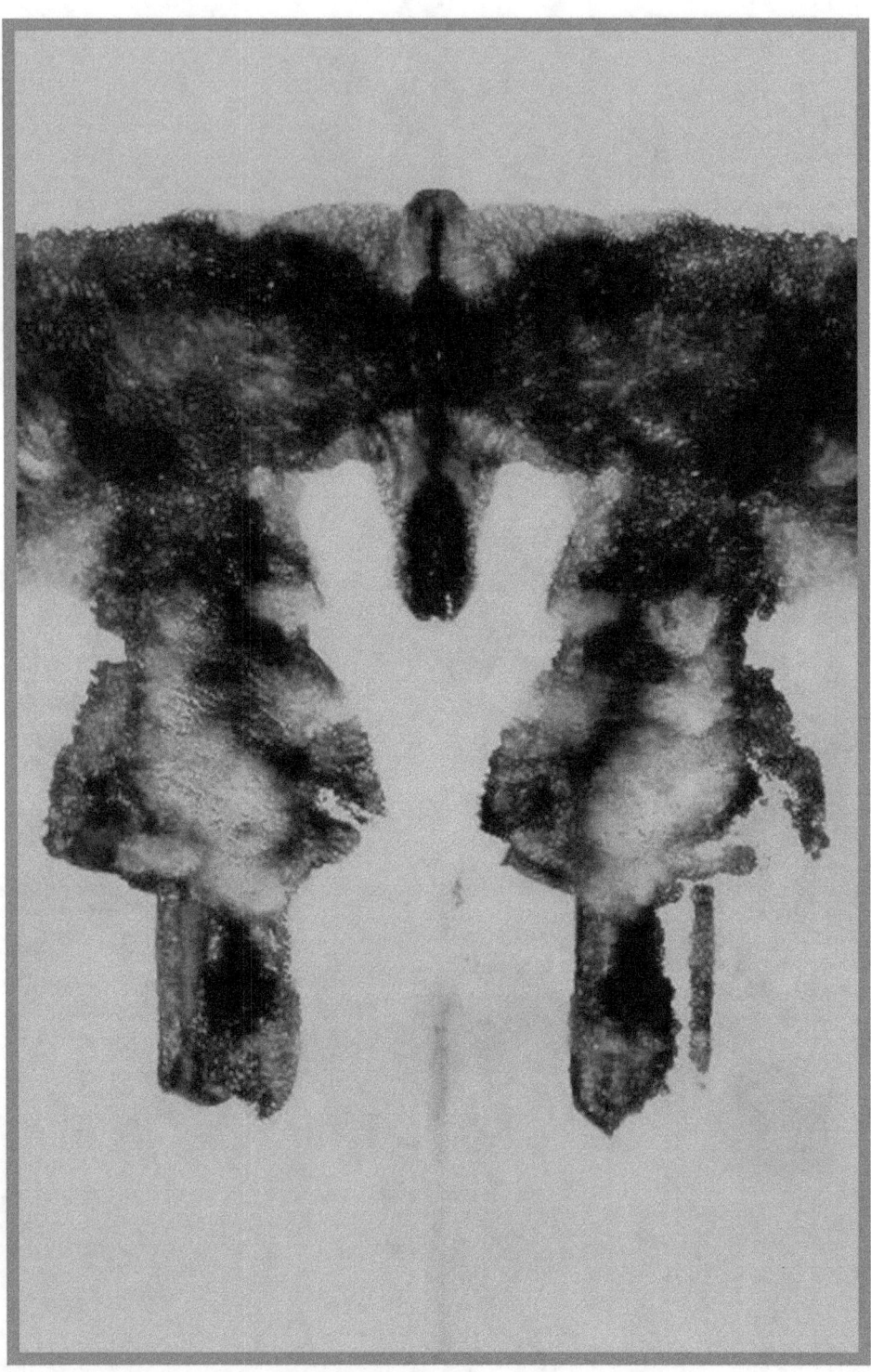

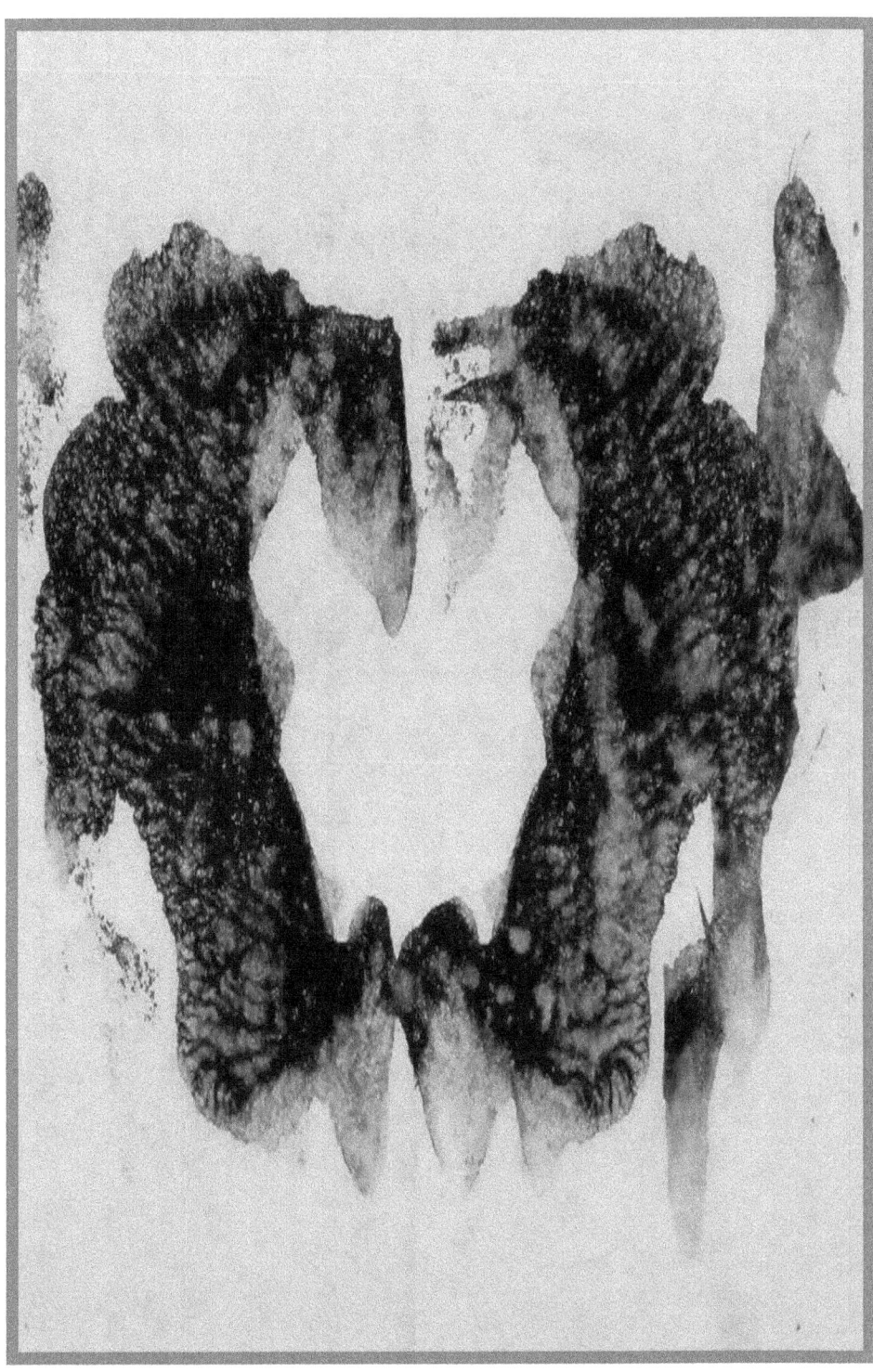

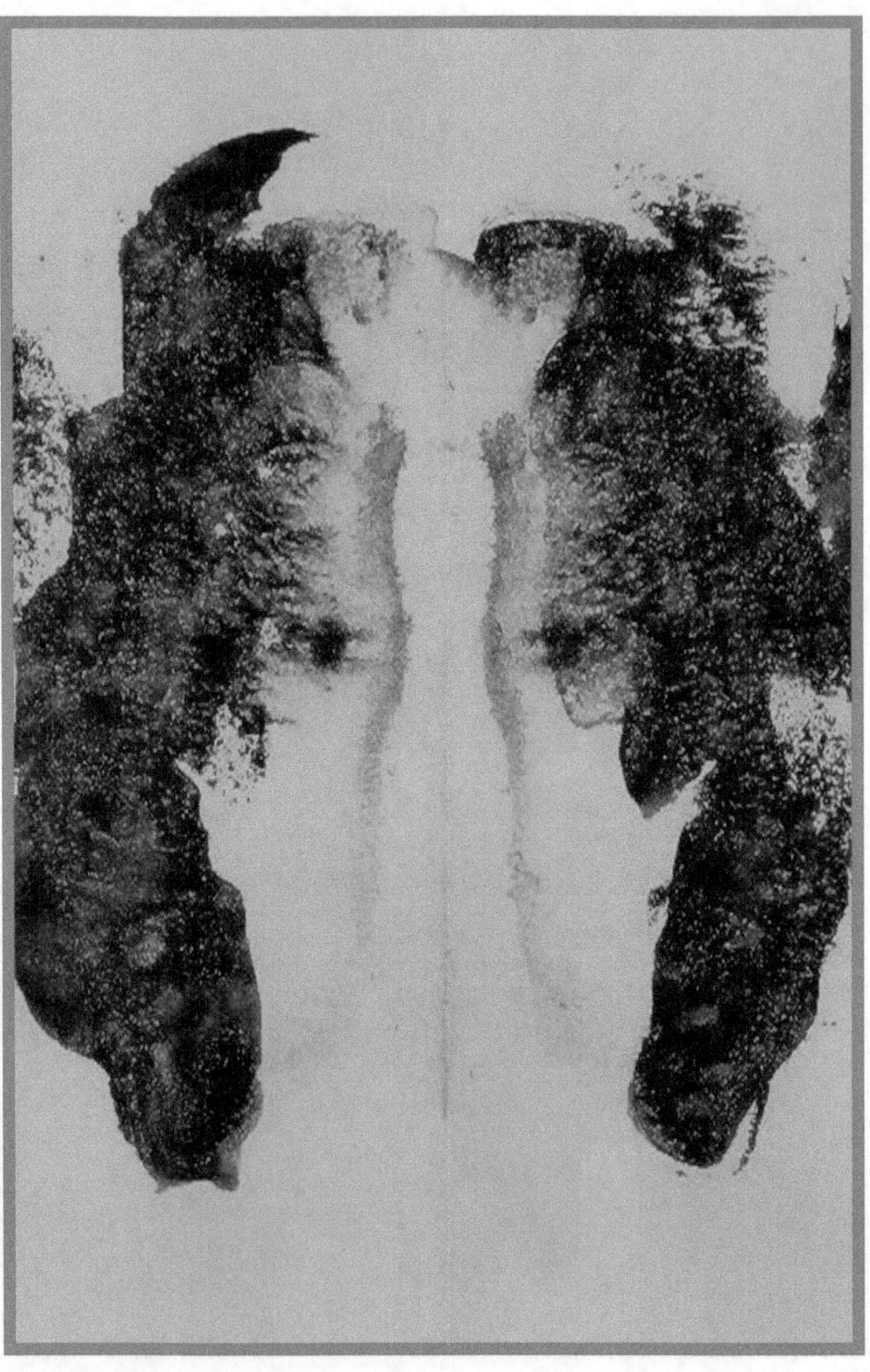

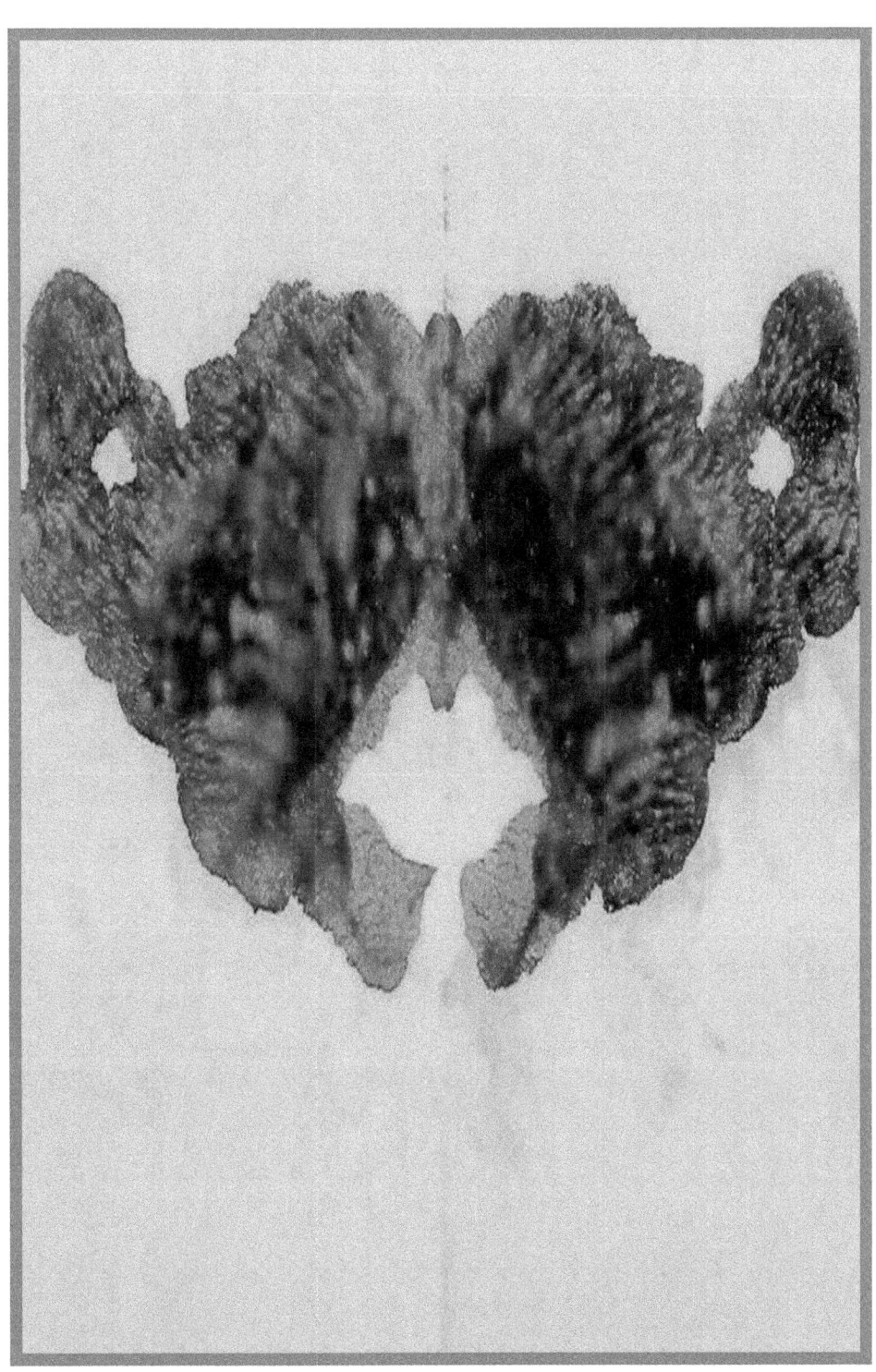

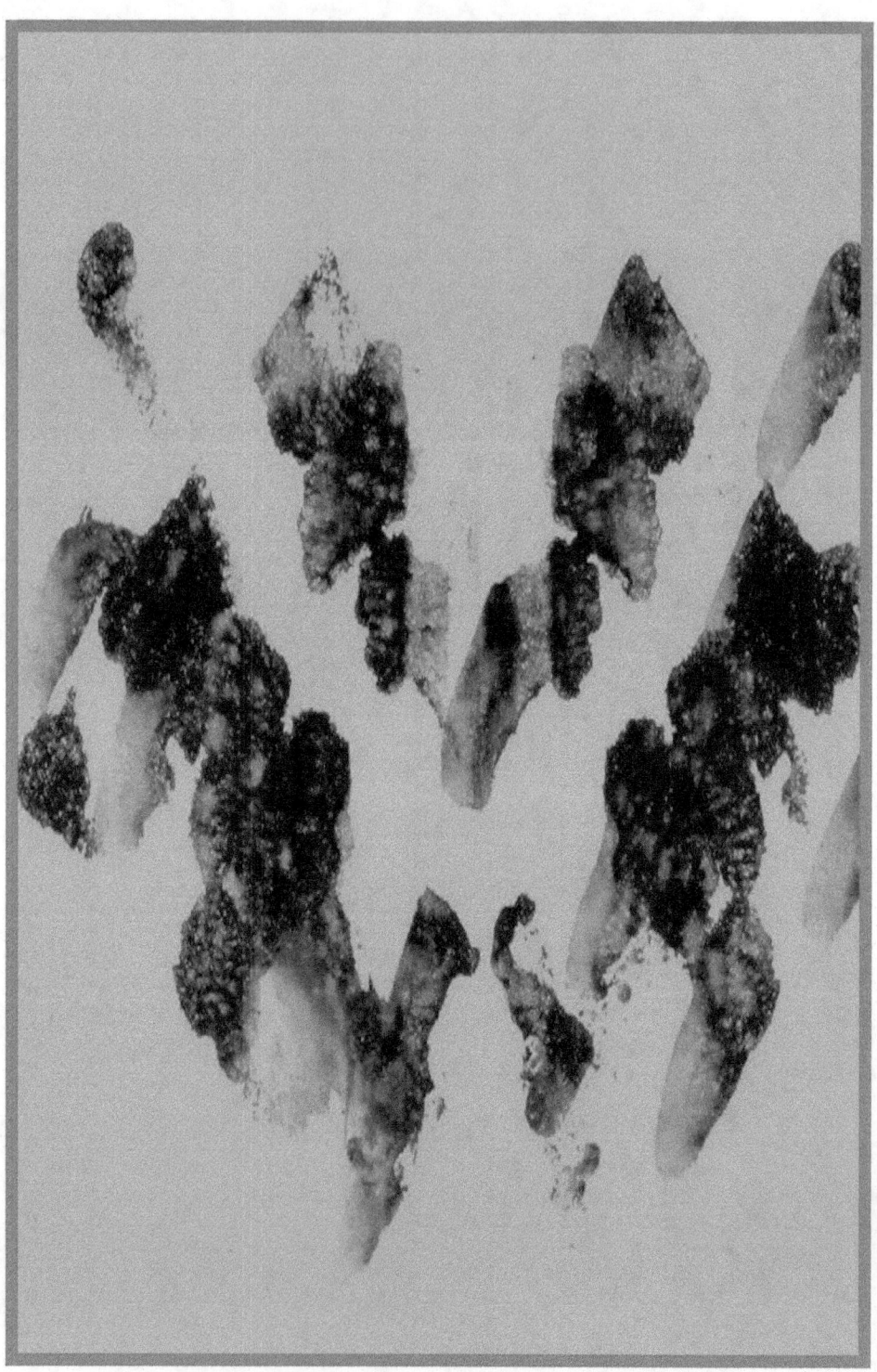

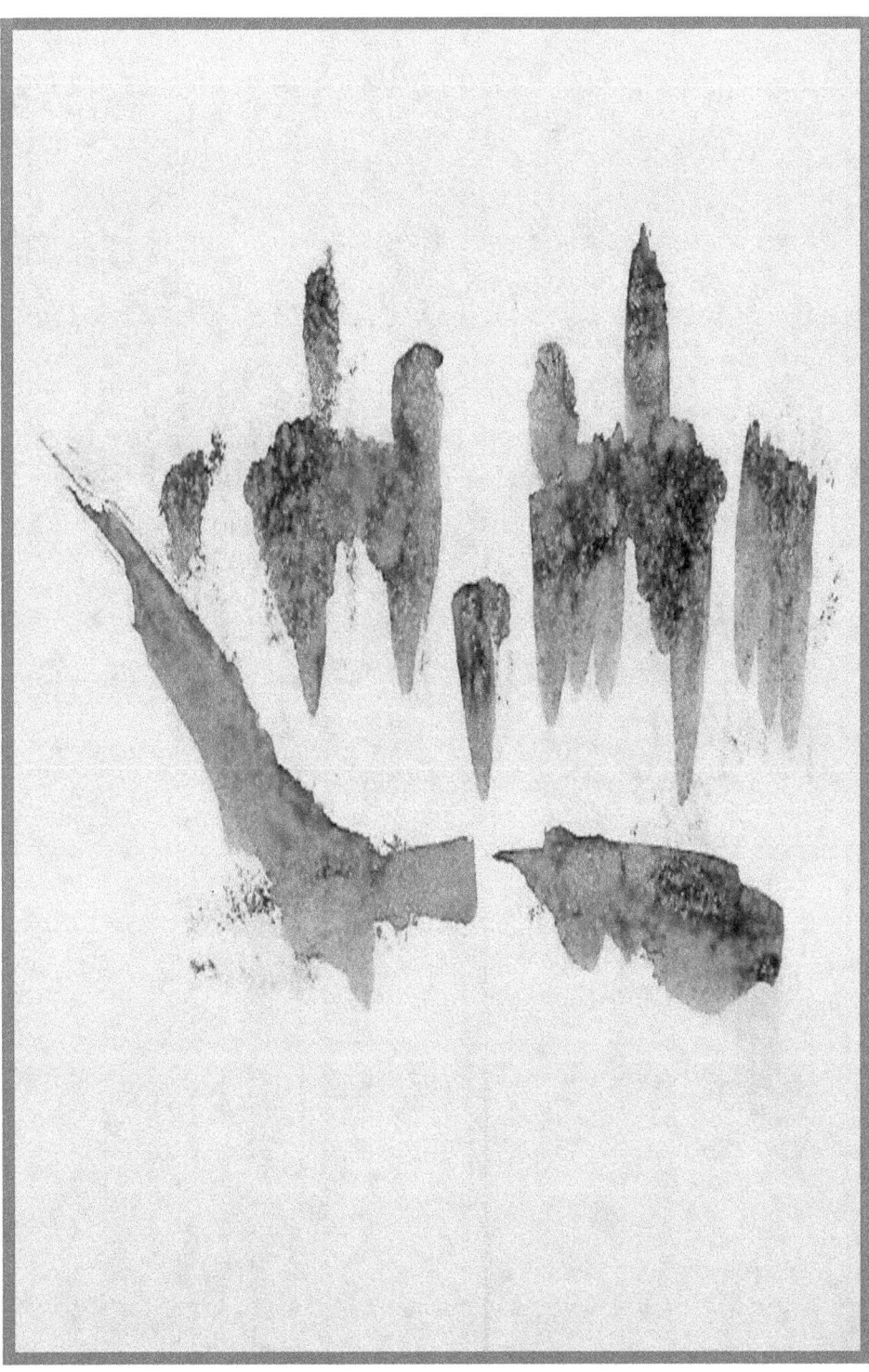

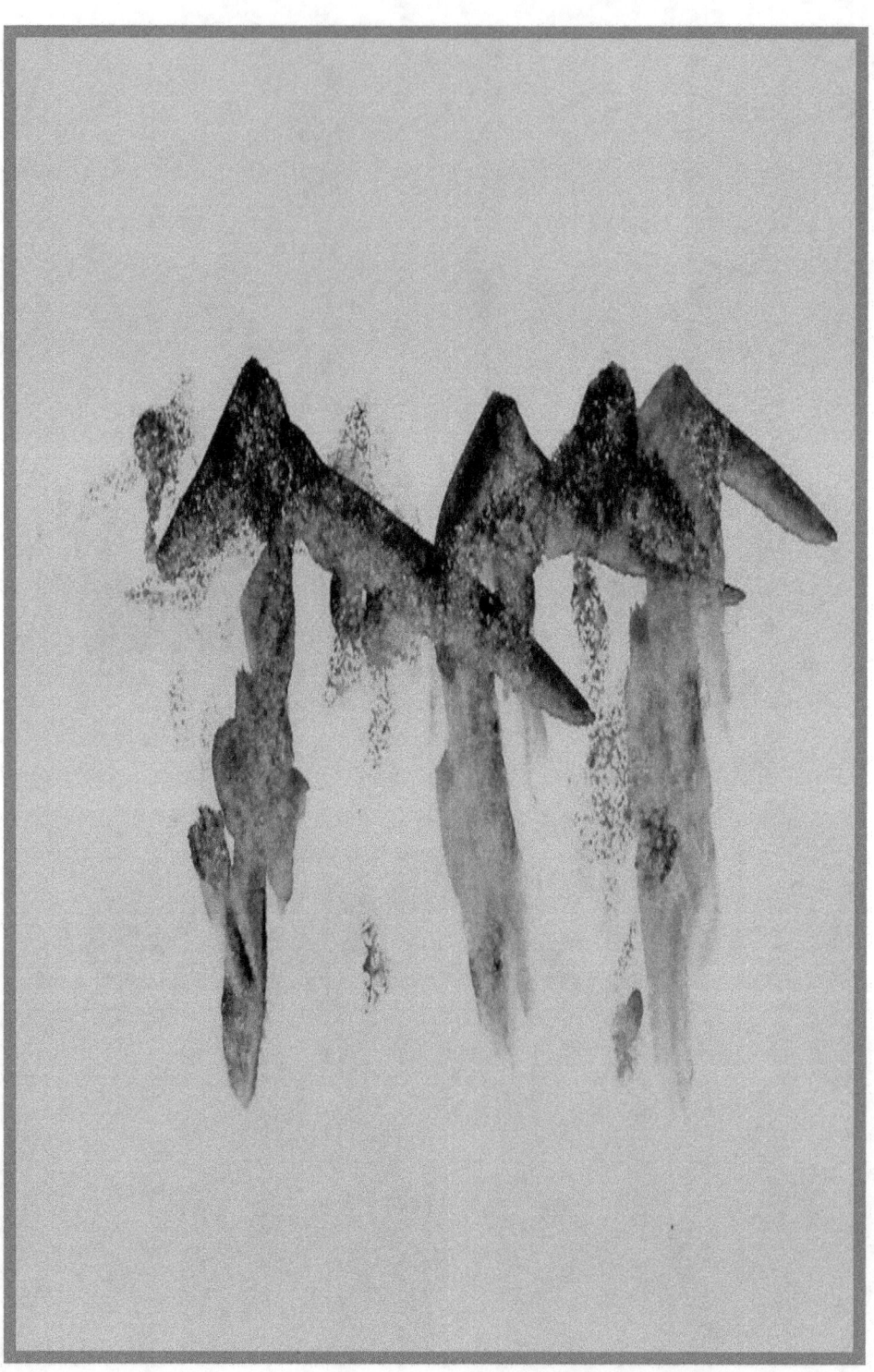

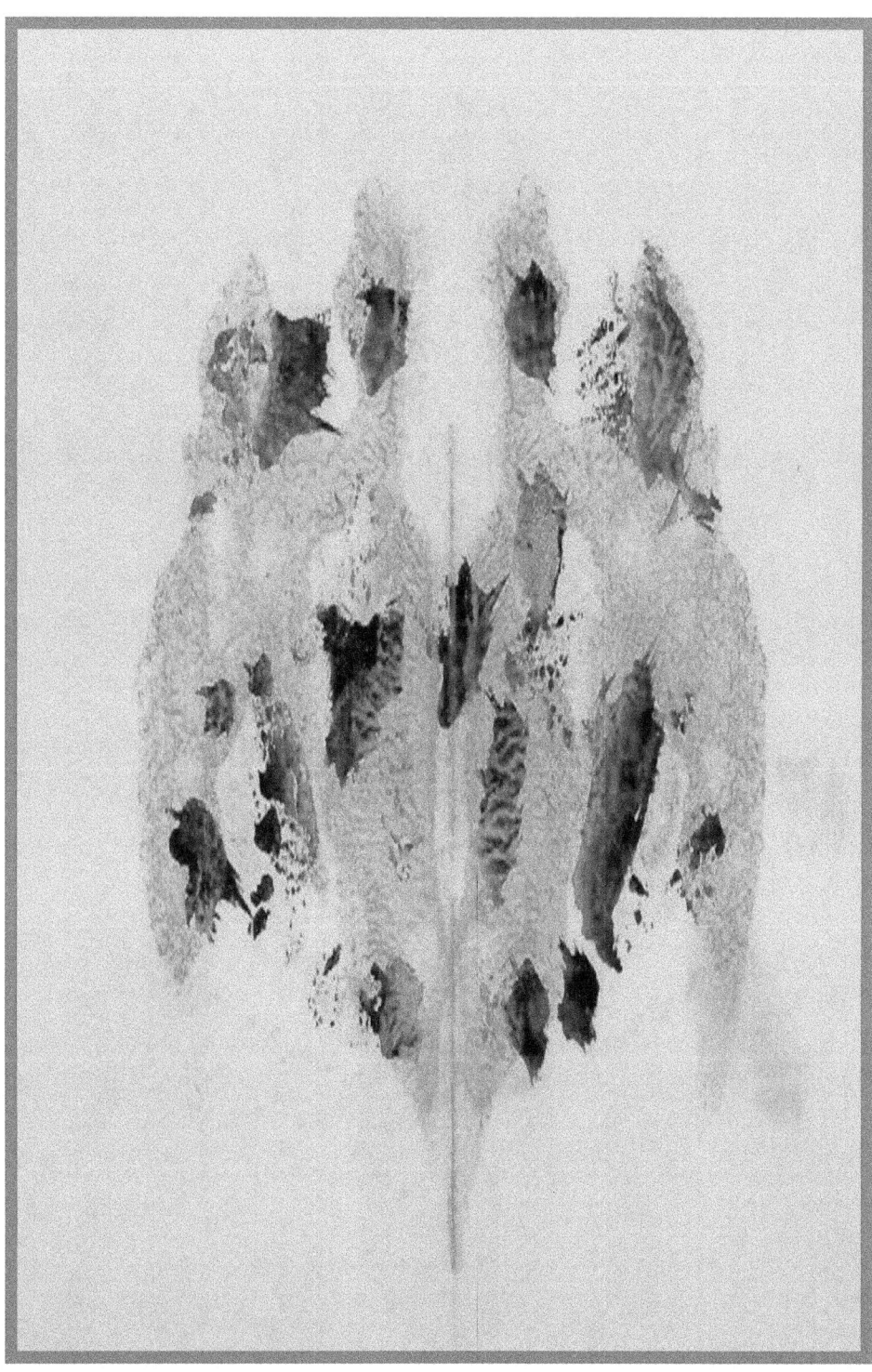

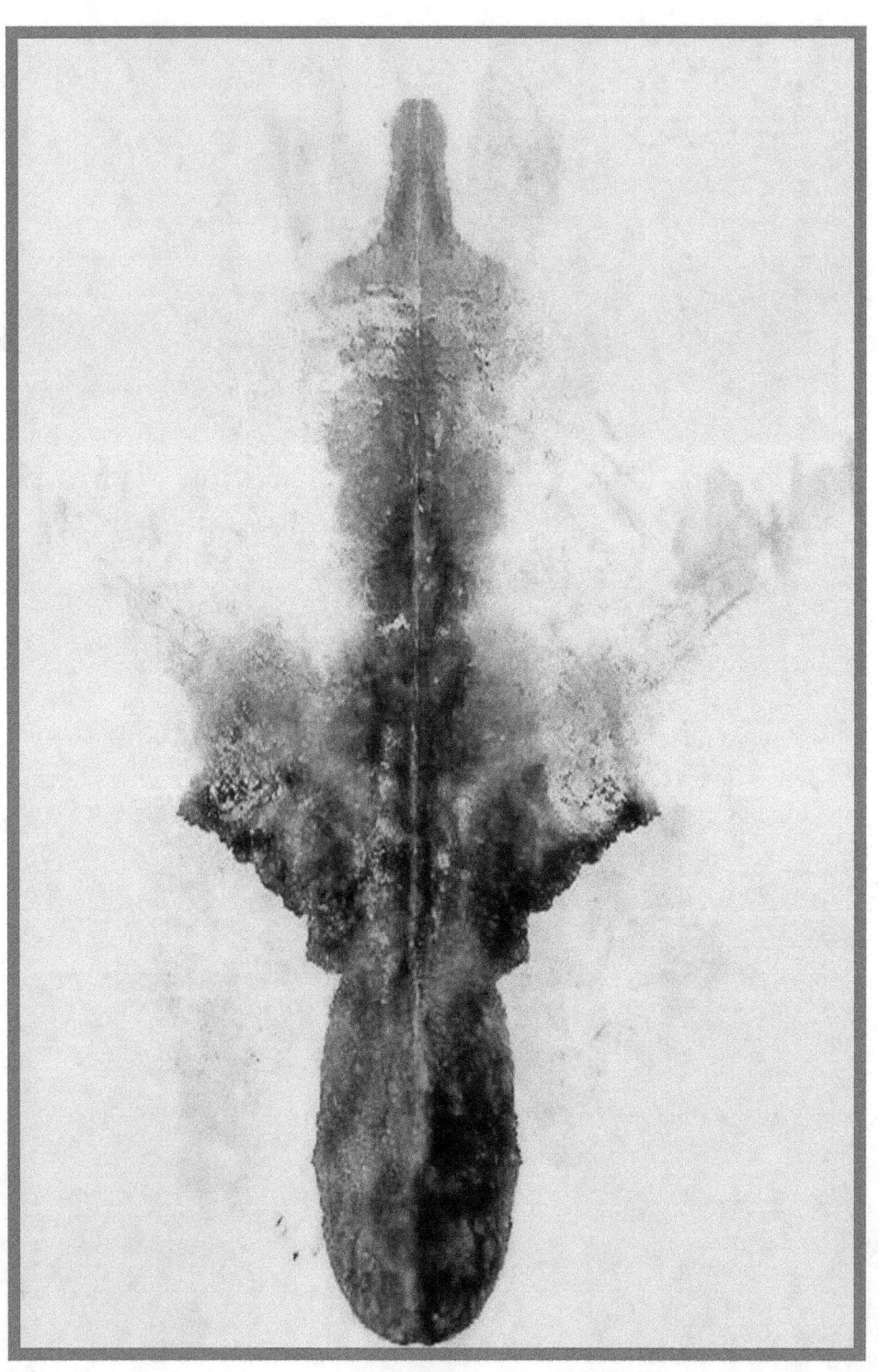

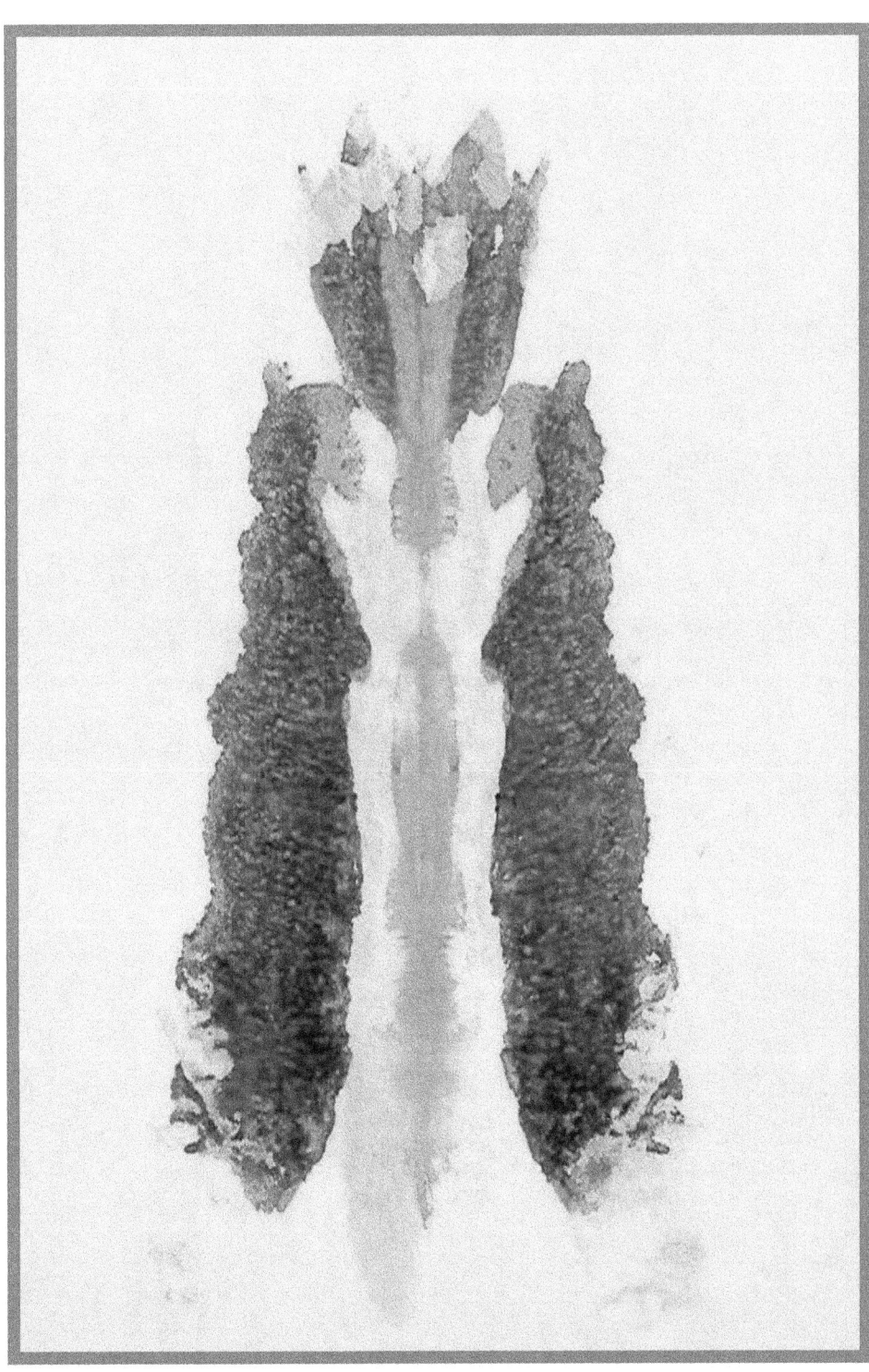

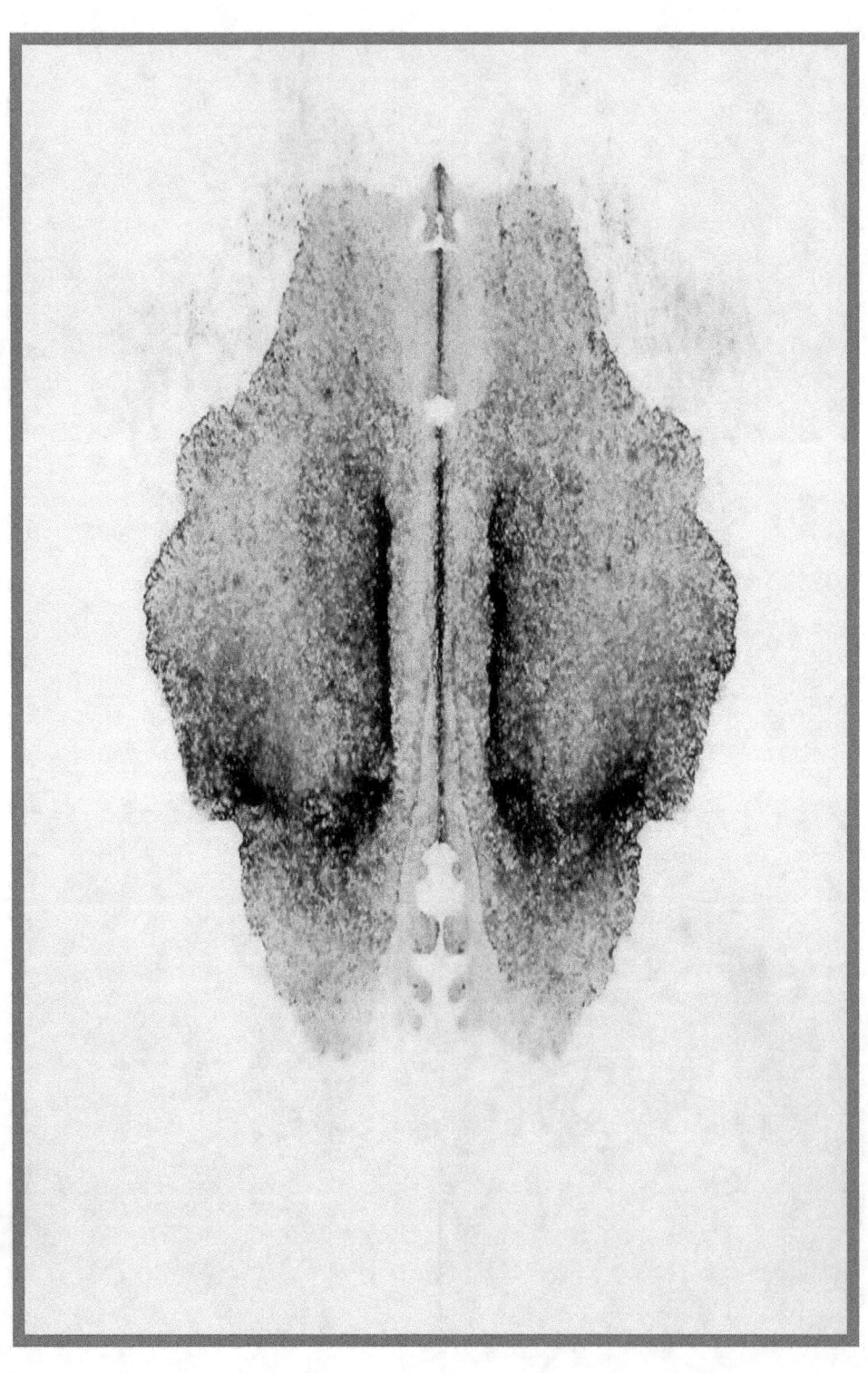

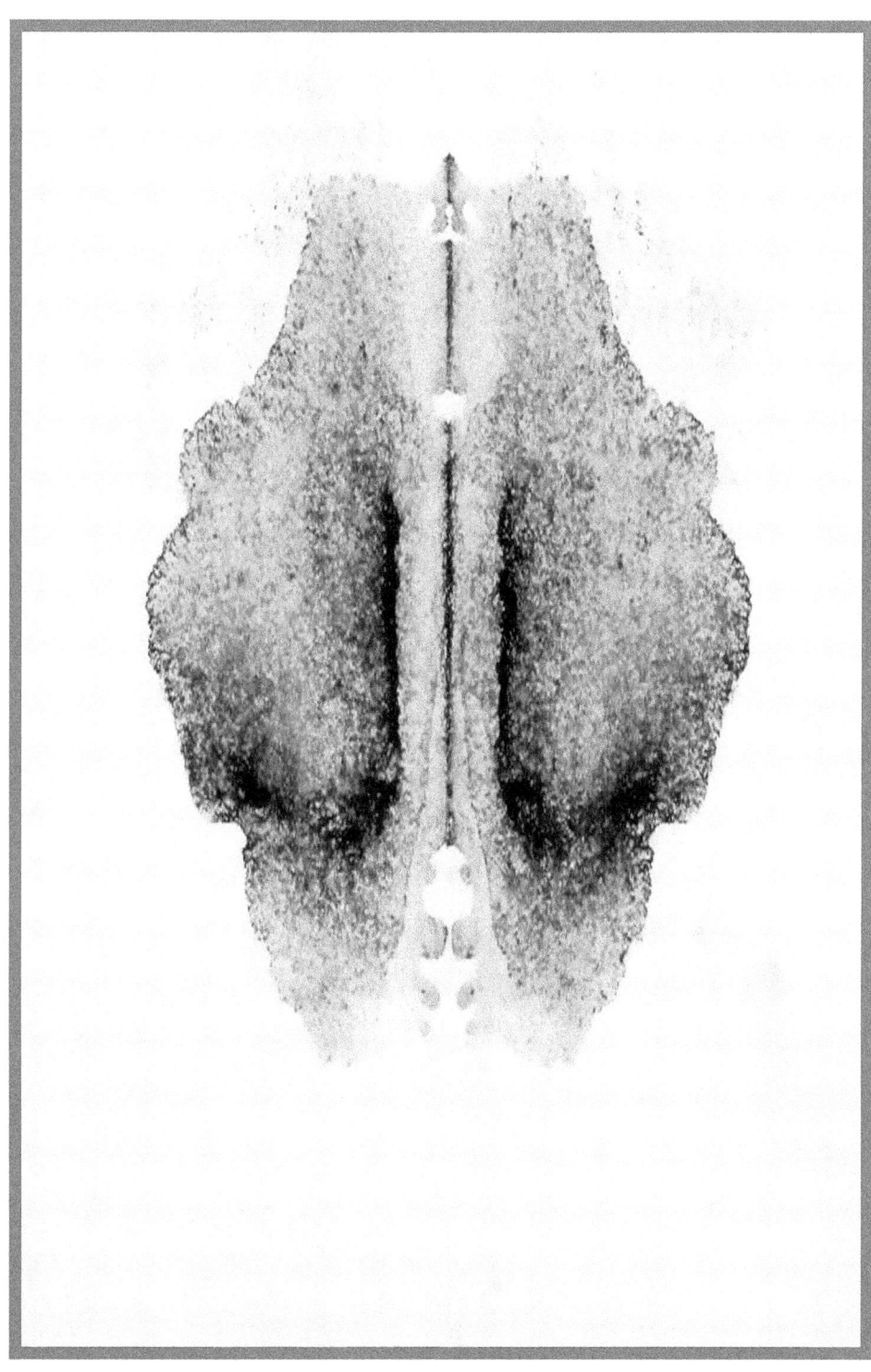

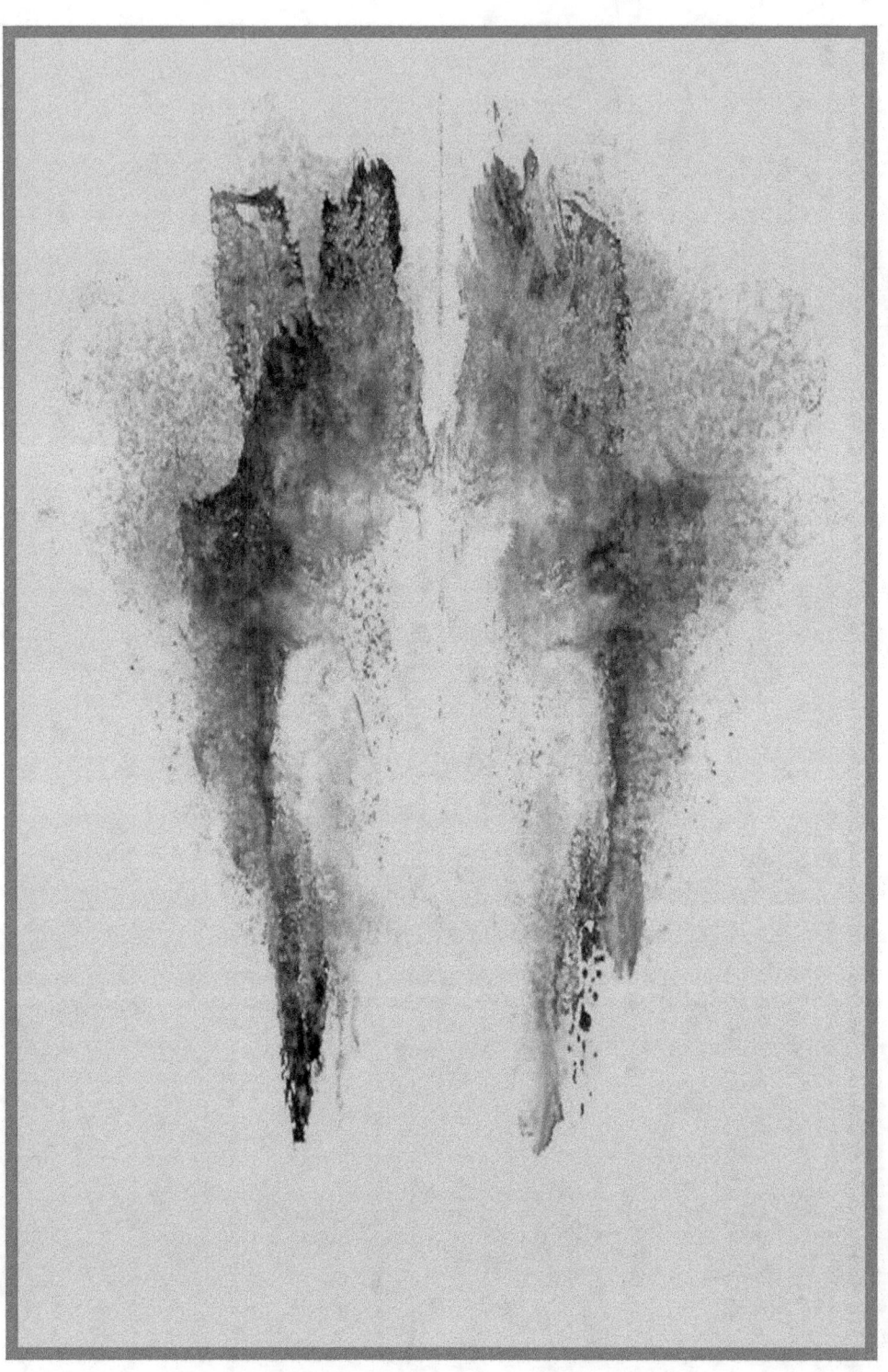

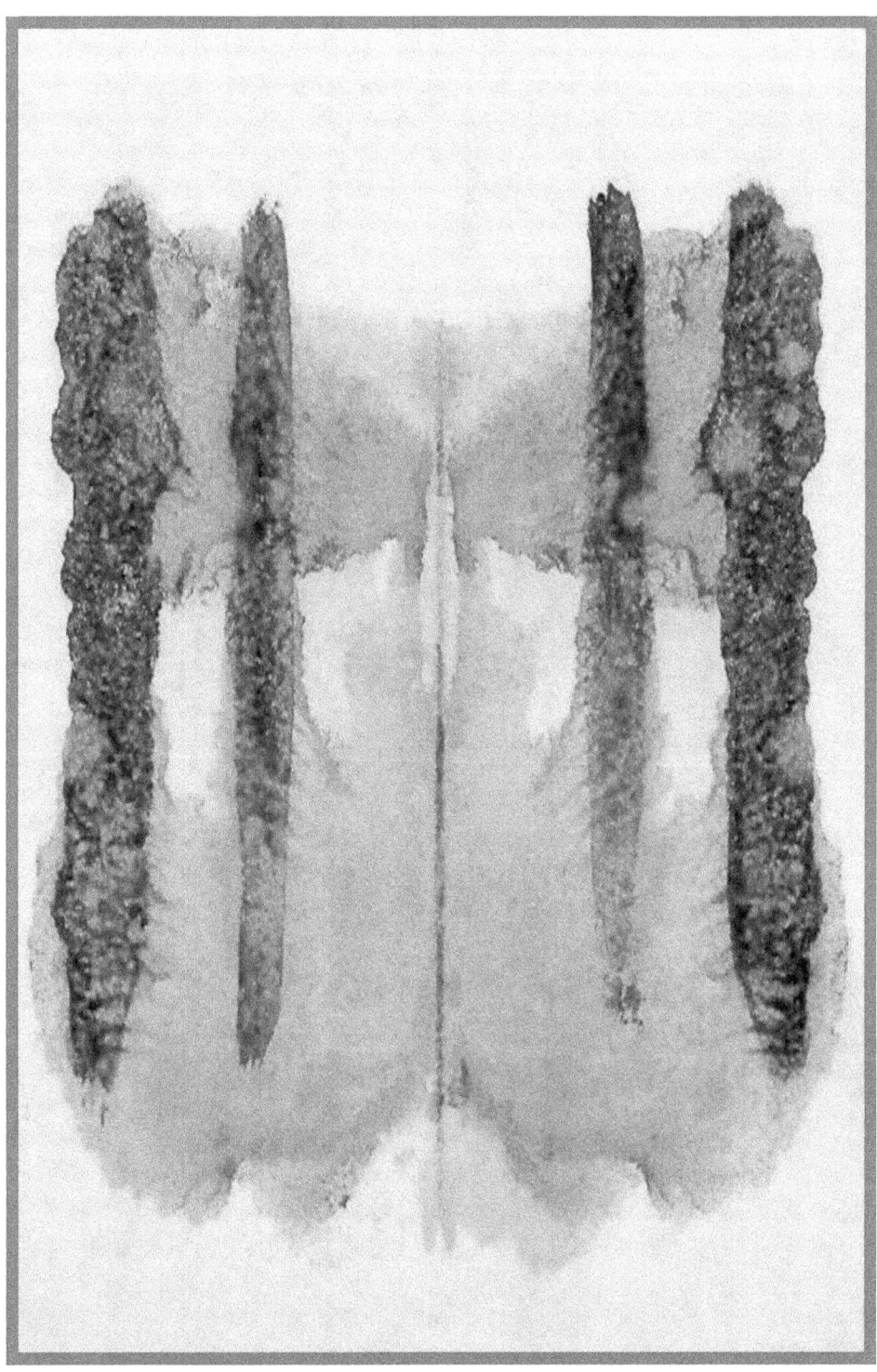

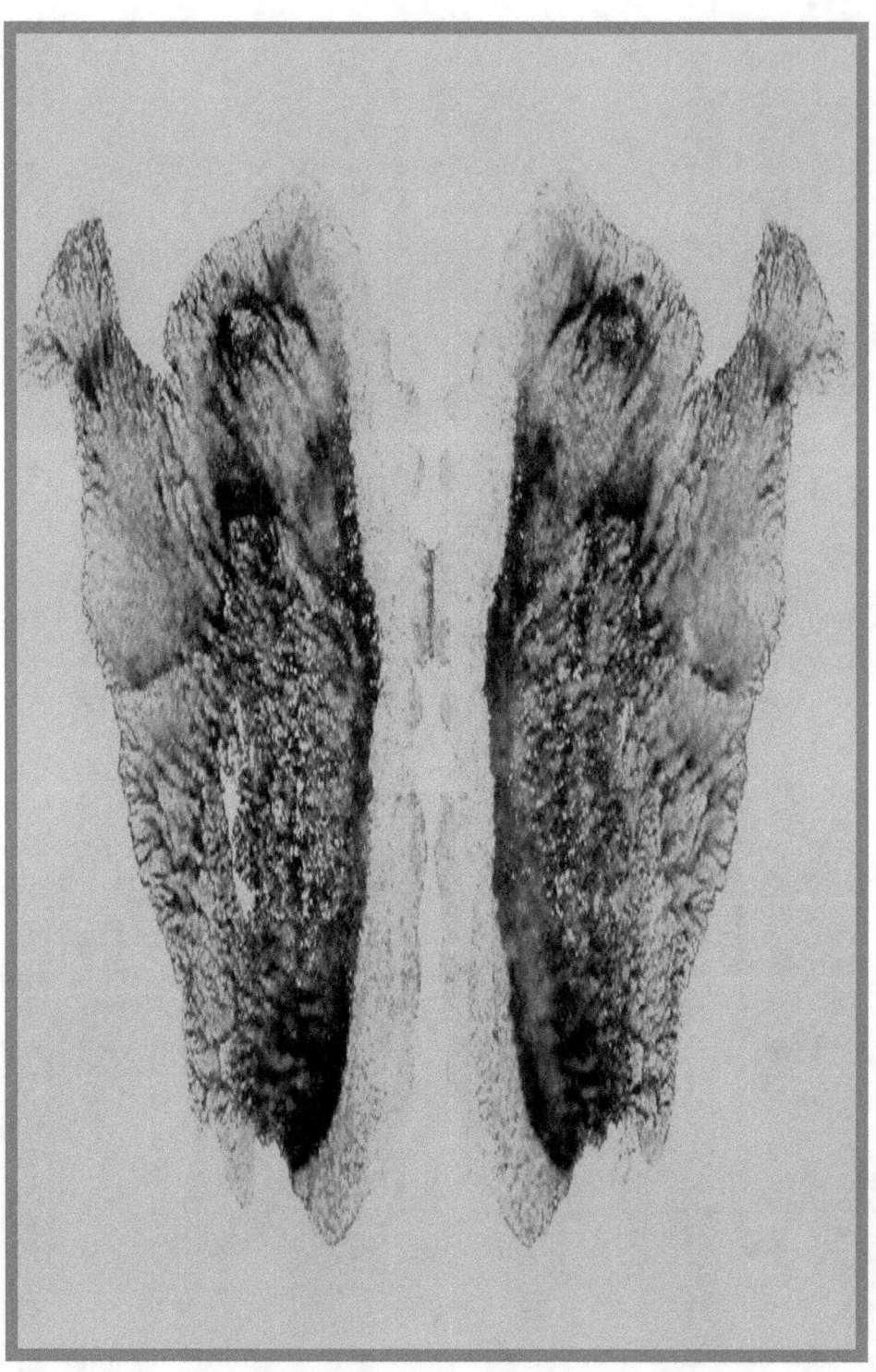

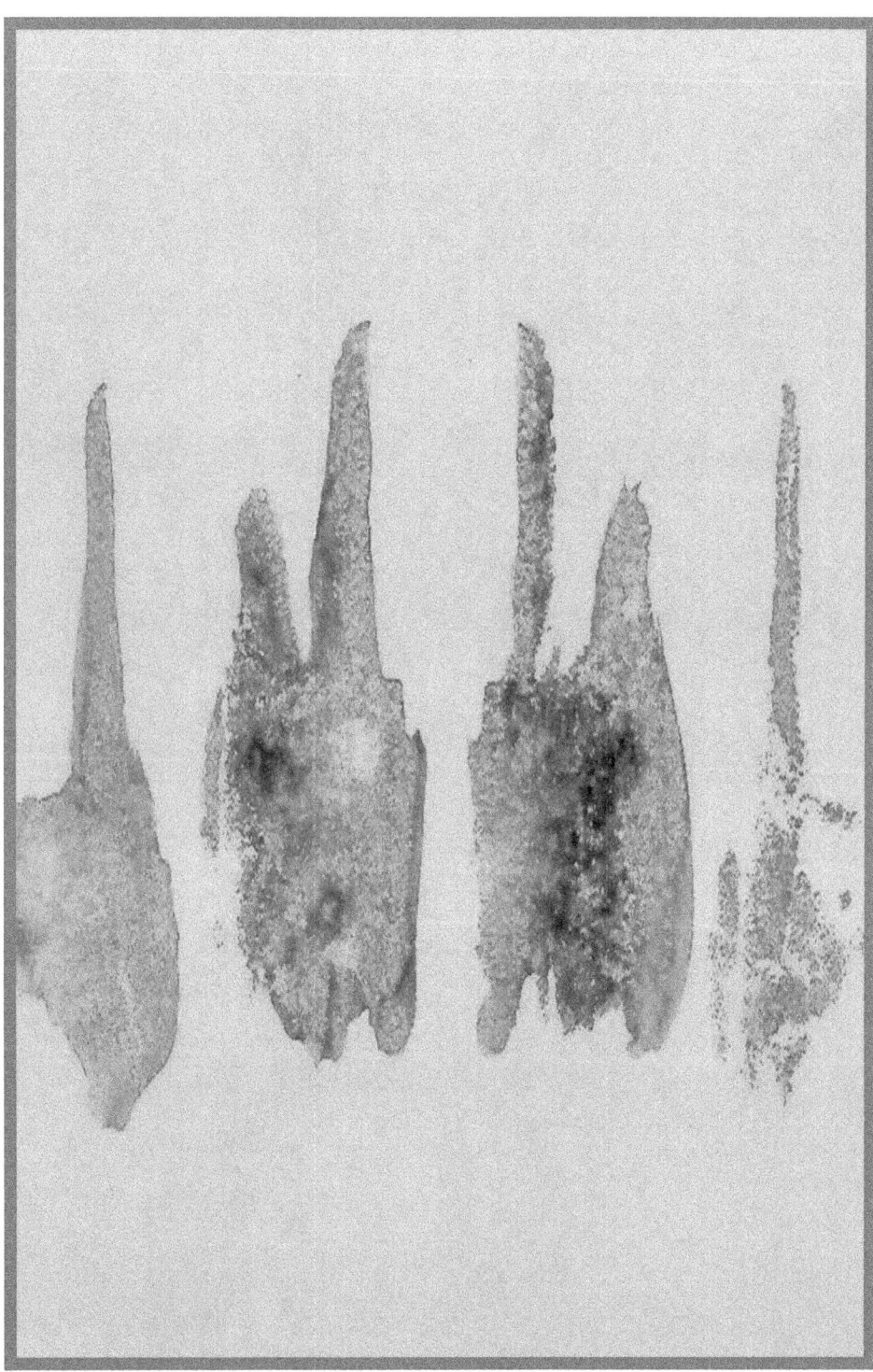

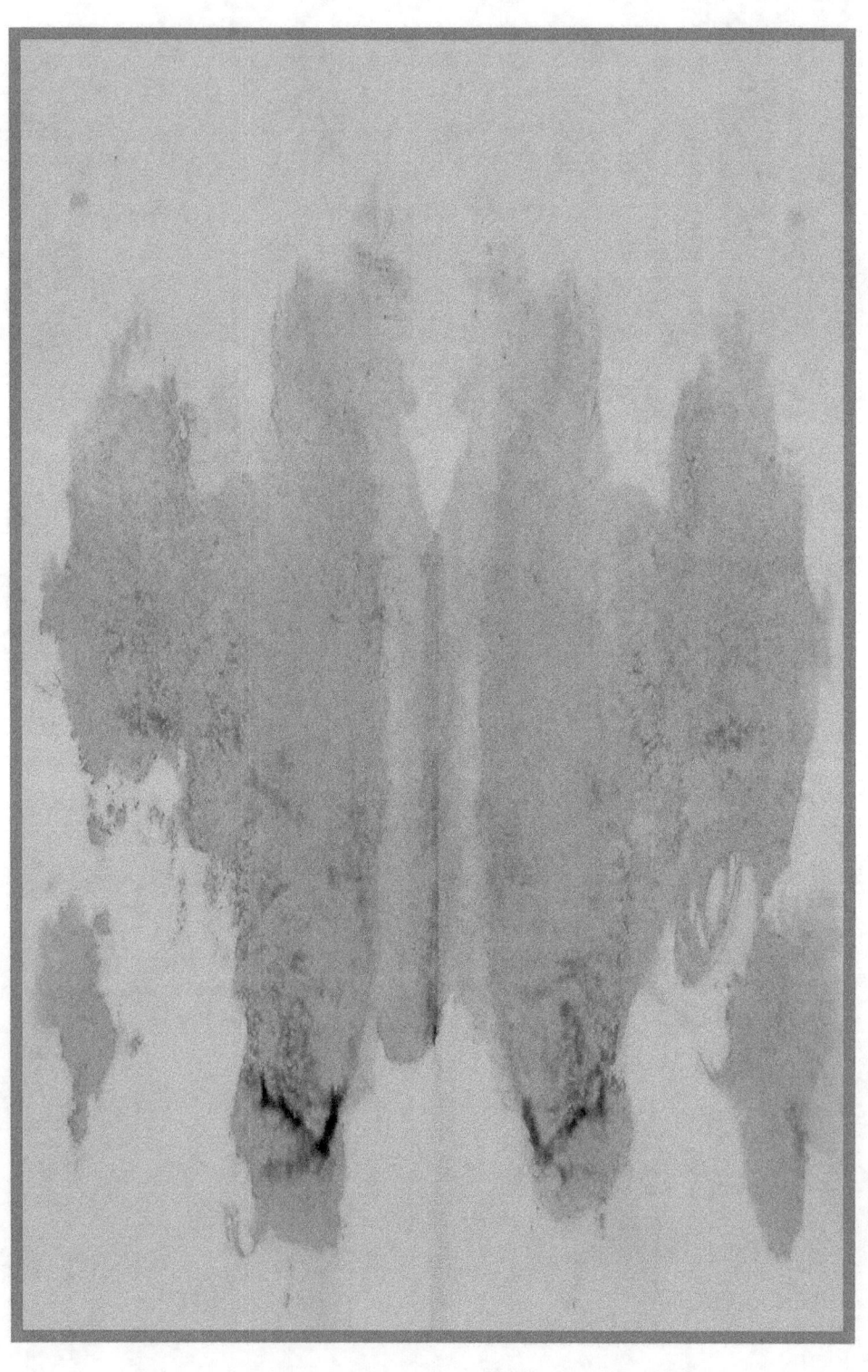

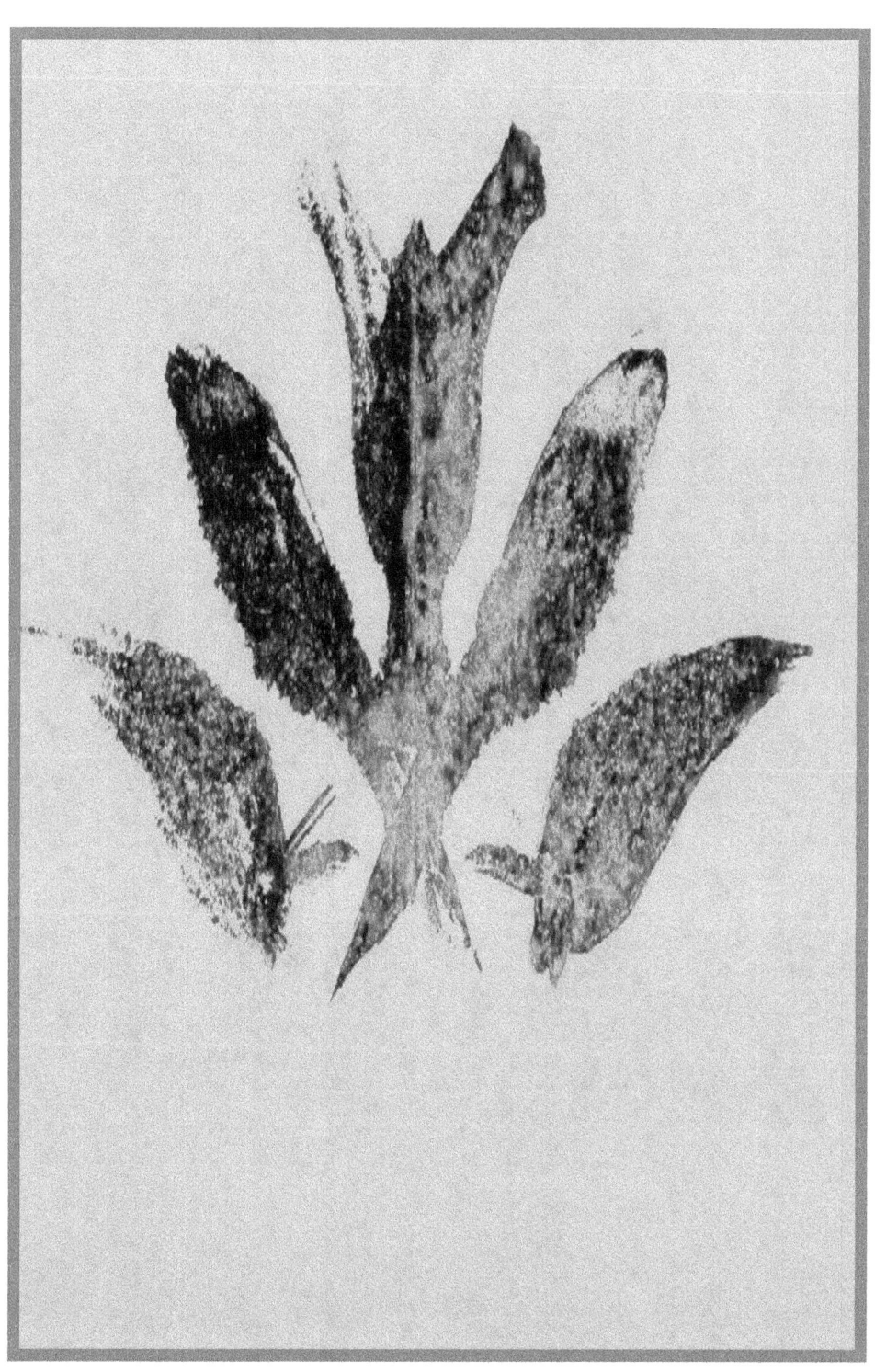

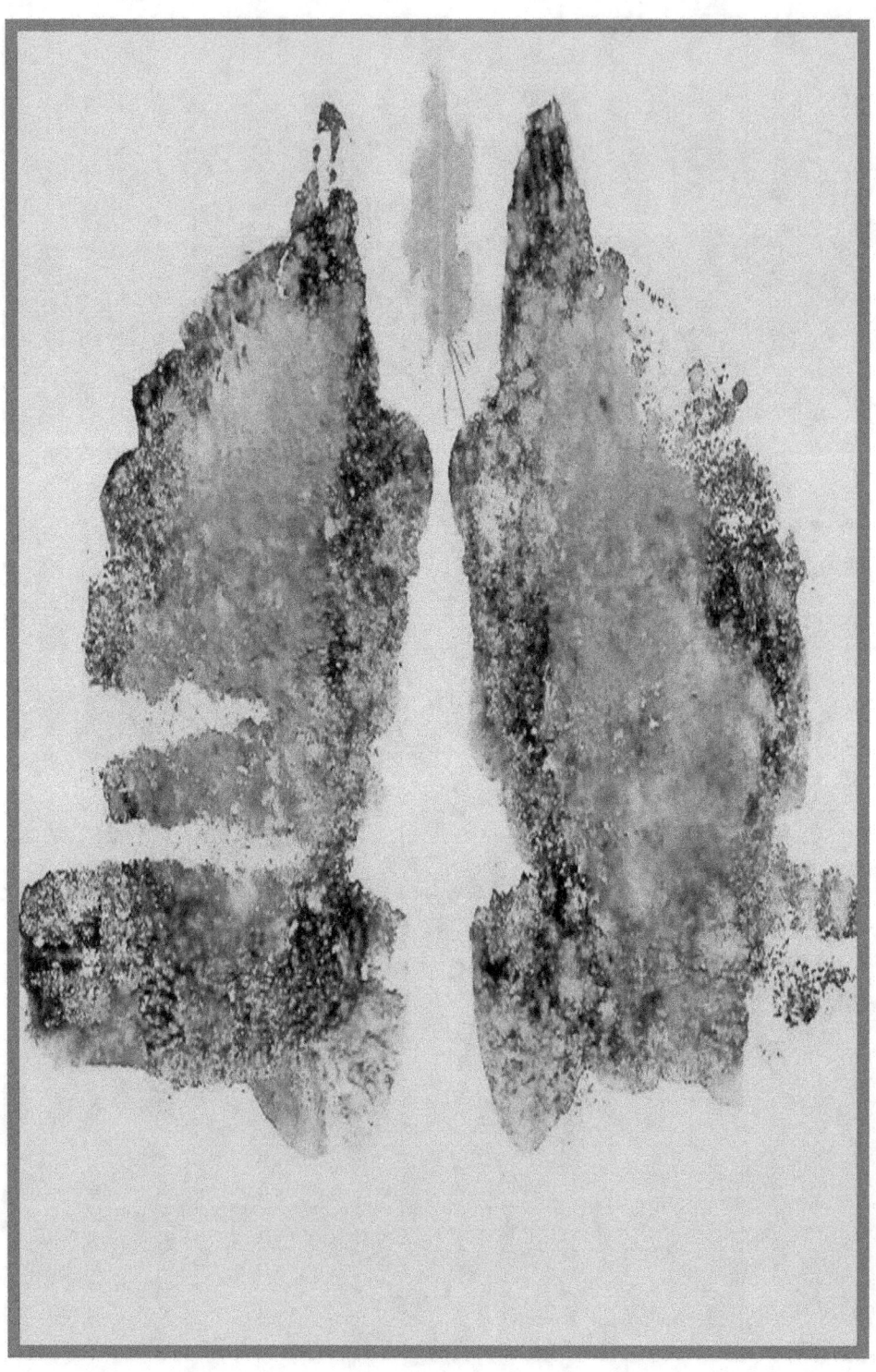

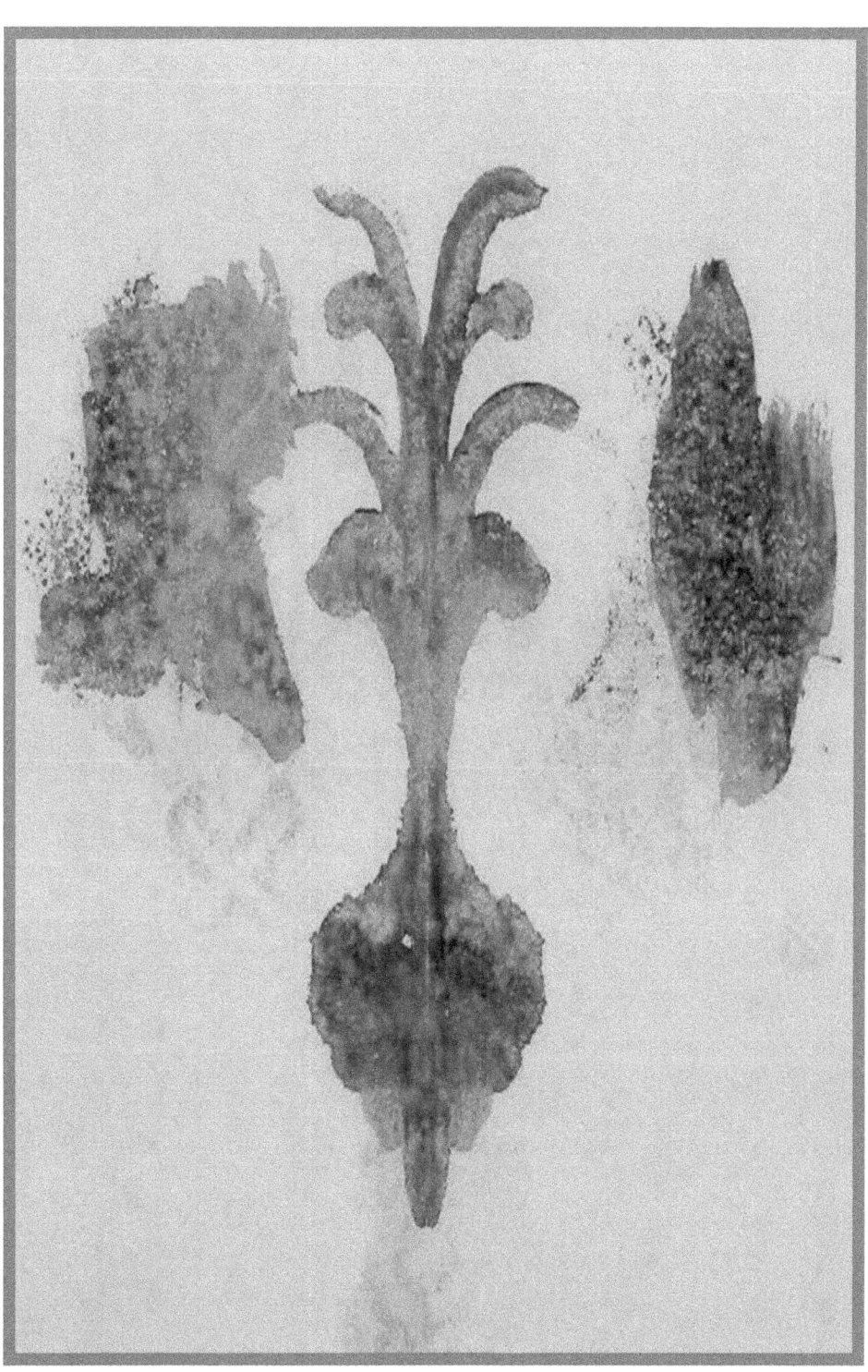

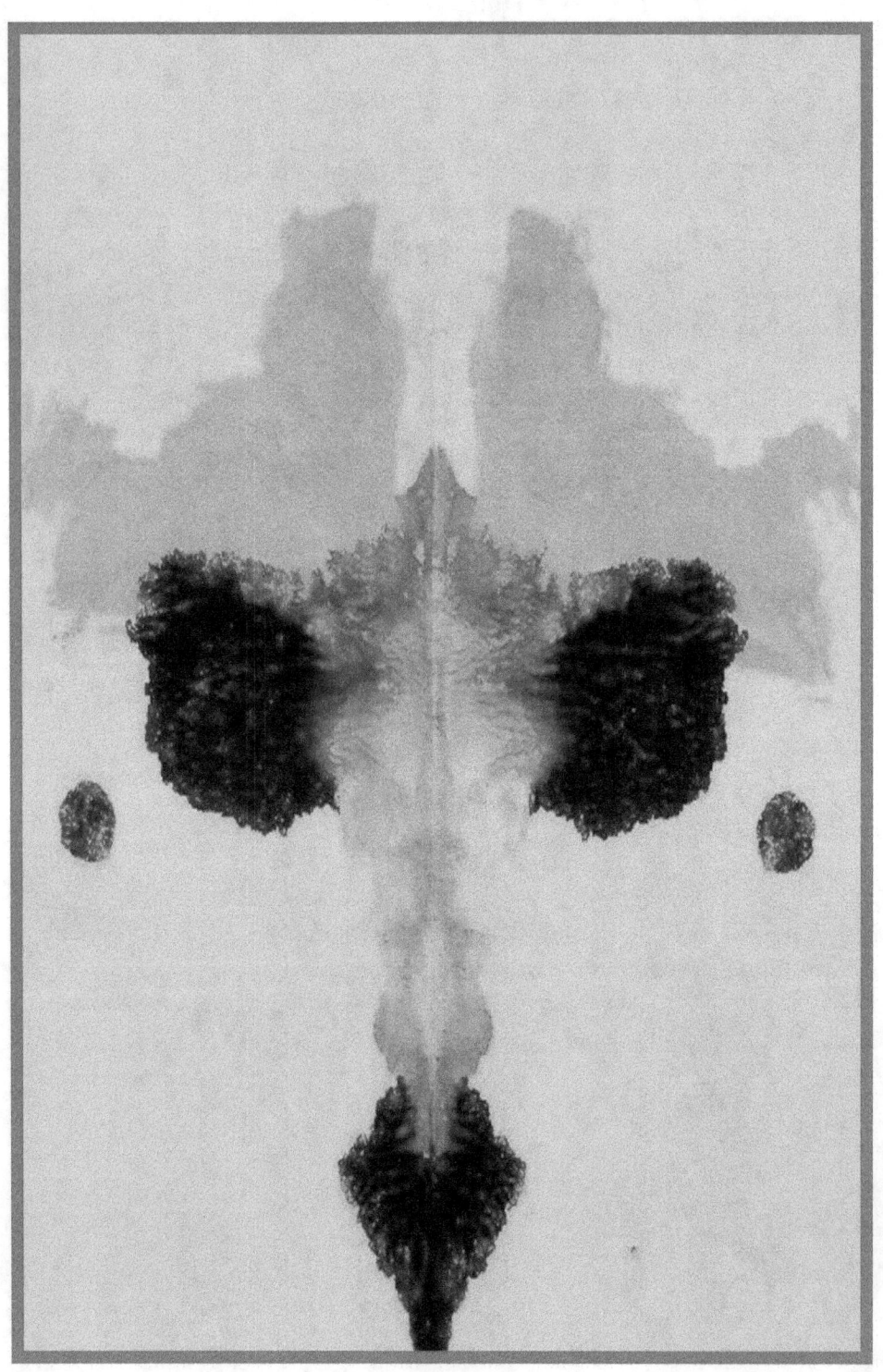

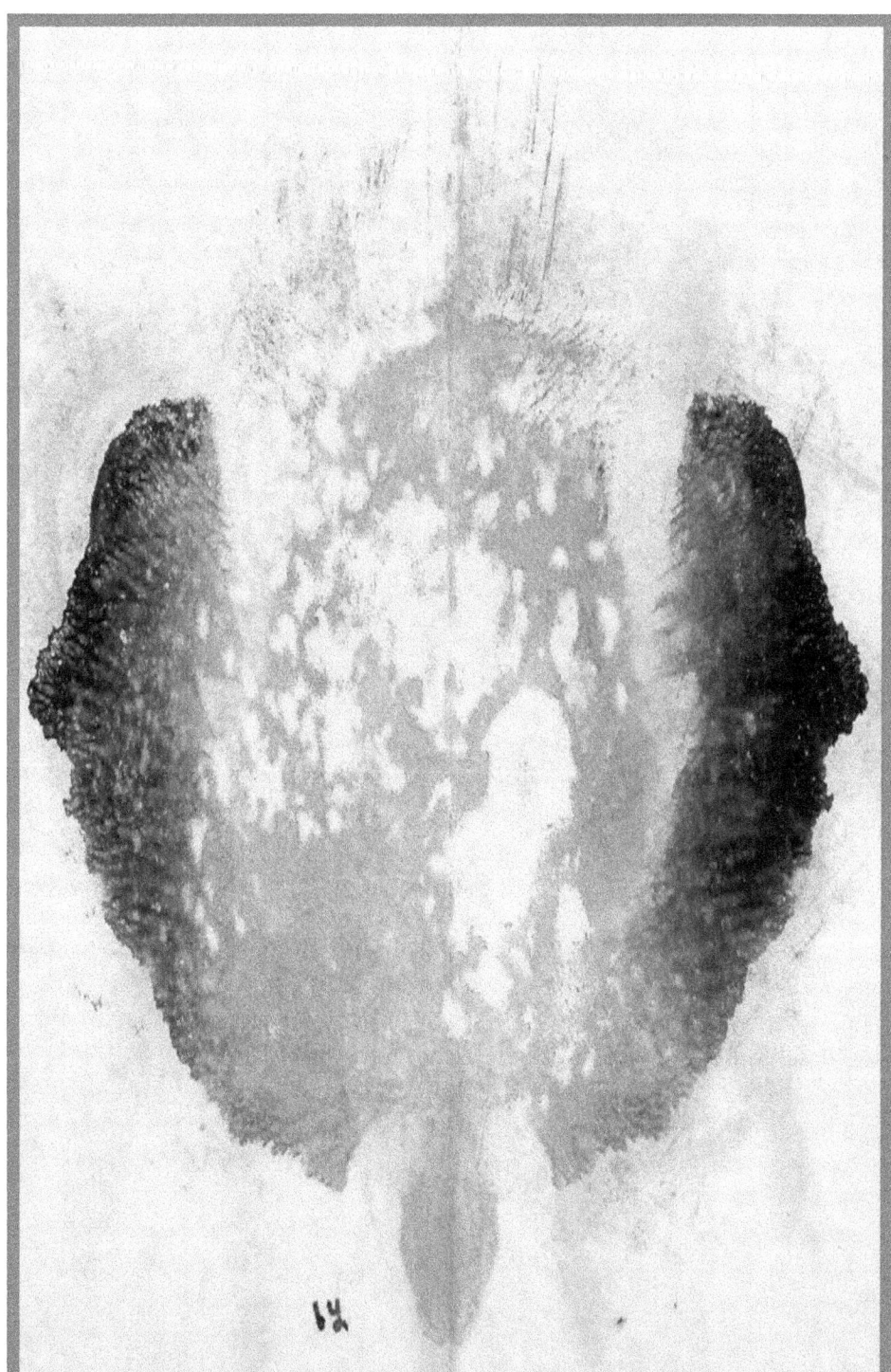

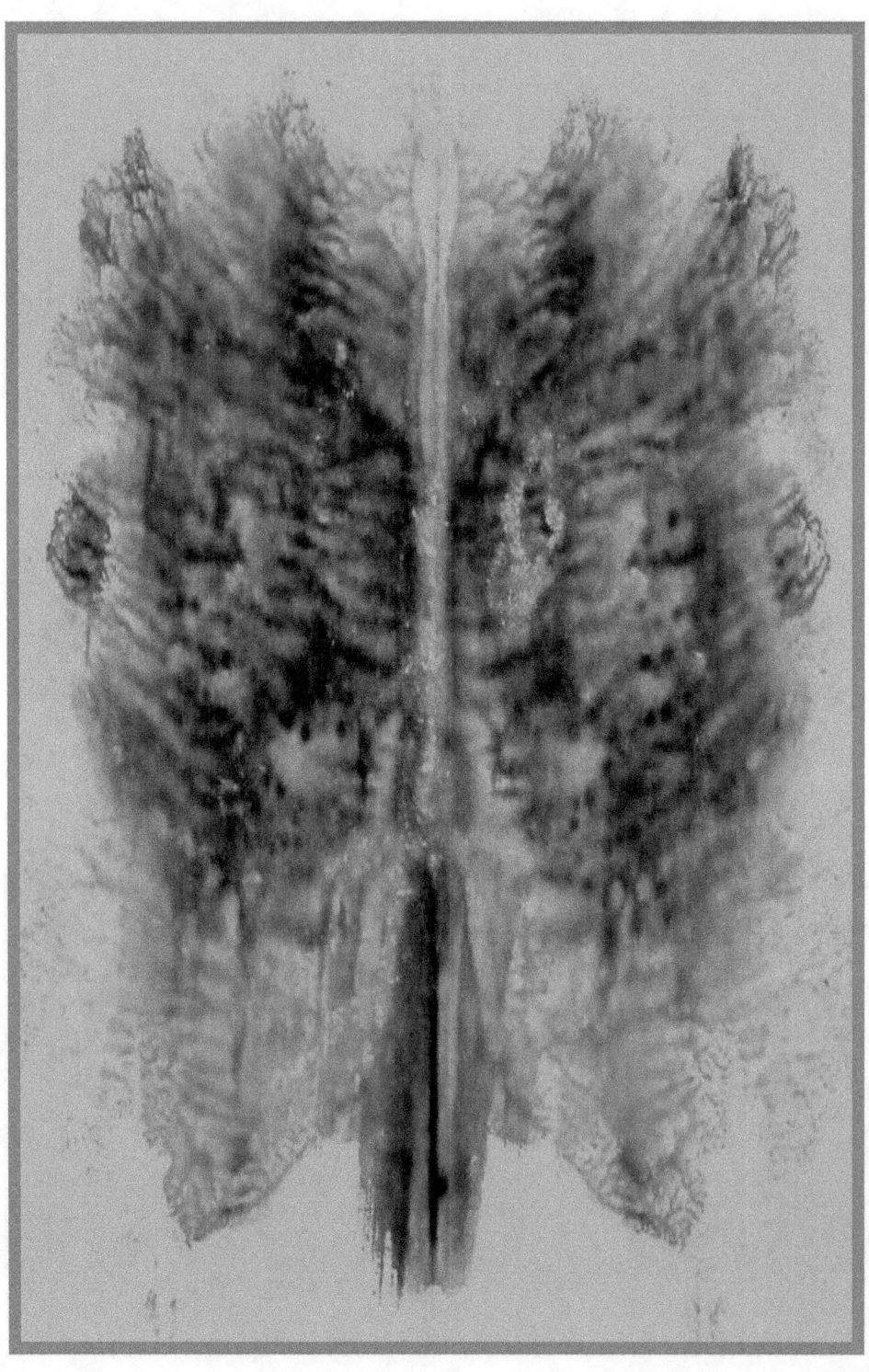

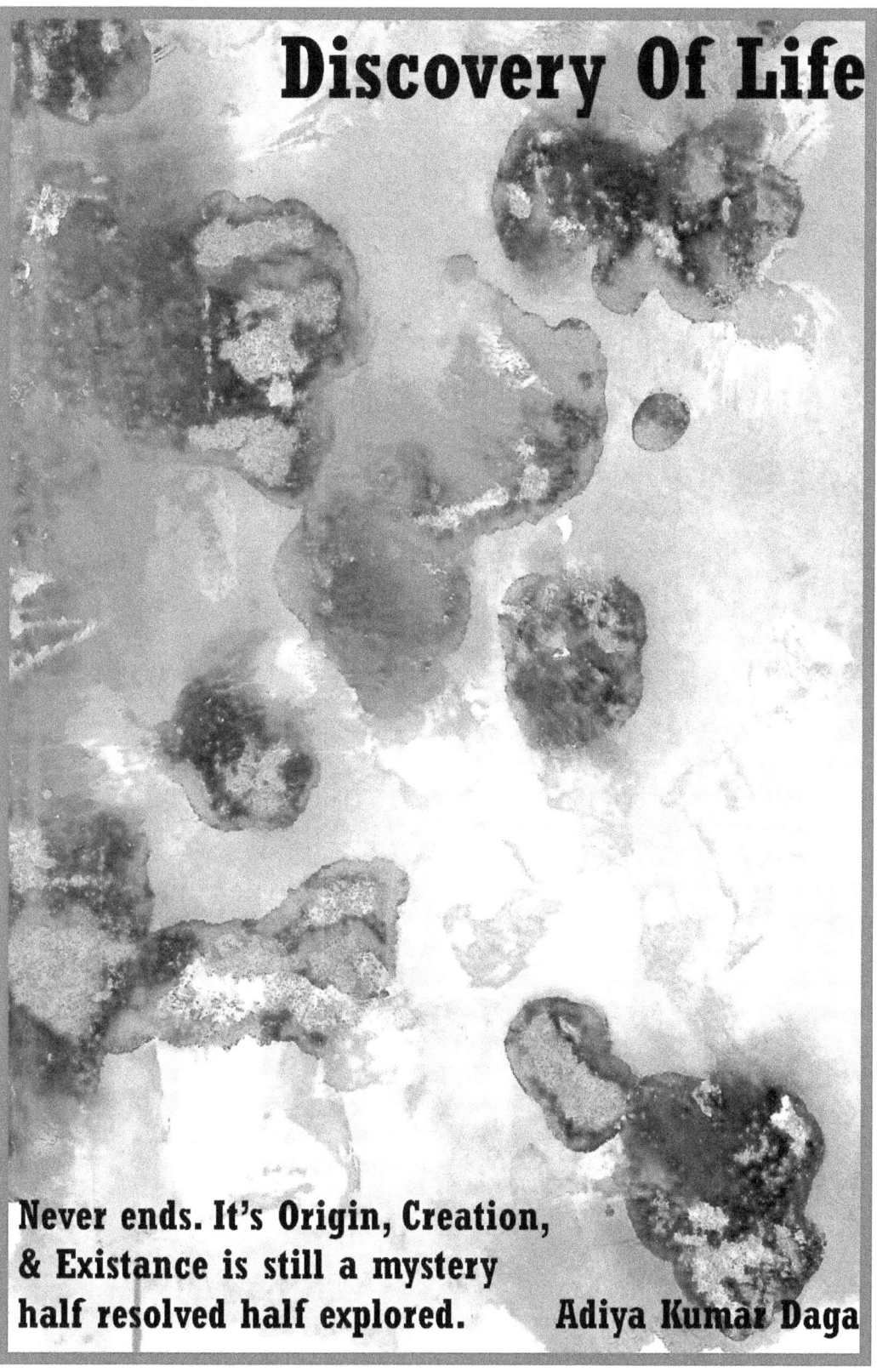

www.ingramcontent.com/pod-product-compliance
Lightning Source LLC
Chambersburg PA
CBHW080525190526
45169CB00008B/3061